the KODAK Workshop Series

Photographing with Automatic Cameras

Photographing with Automatic Cameras

Written for Kodak by Hubert C. Birnbaum

the KODAK Workshop Series

Helping to expand your understanding of photography

Photographing with Automatic Cameras

Written by Hubert C. Birnbaum for Eastman Kodak Company

Kodak Editor: Derek Doeffinger

Book Design: Quarto Marketing Ltd.

212 Fifth Avenue

New York, New York 10010

Designed by Roger Pring

Equipment photography by Tom Beelmann

Cover photograph by Norm Kerr

Picture research by William Paris

© Eastman Kodak Company, 1981

Consumer/Professional & Finishing Markets Eastman Kodak Company Rochester, NY 14650

Kodak publication KW-11 CAT 143 9603 Library of Congress Catalog Card Number 81-67431 ISBN 0-87985-270-4

10-81-GE New Publication
Printed in the United States of America

Throughout this book Kodak products are recommended; similar products may be made by other companies.

KODAK, EKTACHROME, KODACOLOR, KODACHROME, PANATOMIC-X, PLUS-X, DATAGUIDE, TRI-X, and ESTAR are trademarks.

Introduction

It's the age of the automatic camera. Everywhere you turn, you find some-body with an automatic camera slung over the shoulder. On the newsstand, the latest issue of each photography magazine divulges the newest automatic camera and explains how it will simplify photography.

Only a few years ago some photographers thought buying an automatic camera a risky proposition. They didn't relish relinquishing exposure control to electromechanical devices they didn't understand. Today, most people still don't understand how automated exposure works, but they want automatic cameras because they know they do work.

Even if you don't want an automatic camera, you might have to buy one simply because little else is offered. For instance, nearly all current 110 and 126 cameras are automatic. A decade ago, manufacturers of 35 mm cameras offered one or two automatic models to complement their line of manual cameras. Today, the same manufacturers offer one or two manual cameras to complement their line of automatics. The future is clear. It's automatic.

Exactly what is an automatic camera? It's a camera that adjusts its own shutter or lens aperture or both to produce a correctly exposed picture. However, many automatic cameras offer more automation than setting the exposure. Some also have automatic focusing, automatic film advance, and built-in automatic flash.

Just because an automatic camera simplifies picture-taking doesn't mean it's simple to operate. Some are. Some aren't. Good evidence that camera automation isn't synonymous with simplicity is the length of the camera manuals accompanying

some automatic cameras. Some are as long as a hundred pages. That's a lot of simplicity.

The most basic automatic cameras are point-and-shoot machines that require little more of the photographer than pushing a button. That's simple. If your photographic needs are limited, these cameras will serve you well.

More complex and challenging photographic pursuits, however, require more complex and versatile cameras. In addition to pushing a button, you must also set or monitor the shutter speed and lens aperture, and consider how they will affect the picture. That's not so simple. Fortunately, the actual operation of even complex cameras is fairly easy. Whether your camera is complex or simple, study your camera manual and carry it with you until you're confident operating your camera.

In this book we'll introduce you to the different types of automatic cameras and accessories, such as zoom lenses and electronic flashes. We'll study the camera controls and show you how to use shutter speed and lens aperture settings to improve your pictures. We'll also take a long look at the essence of automatic cameras—automatic exposure. Automatic exposure isn't perfect, so you need to know when to override your camera's exposure setting and how to get the right exposure.

The purpose of automation is to free you of setting exposure so you can concentrate on the subject. To help you concentrate on the subject, we'll develop your awareness of light, color, composition, and other elements important in rendering the subject. If you have a favorite subject, such as people, landscapes, or action, you'll also find specific tips and techniques.

An automatic 35 mm single-lens reflex (SLR) camera can cope with complex photographic situations through a wide range of available accessories.

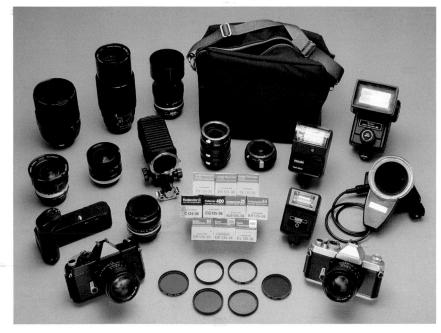

Contents

Automatic Cameras 8
Exposure Meters and
Exposure16
Lenses
Camera Handling32
Electronic Flash
Accessories
About Film52
Elements of the Picture 58
Composition70
The Subject
Recommended Reading 94

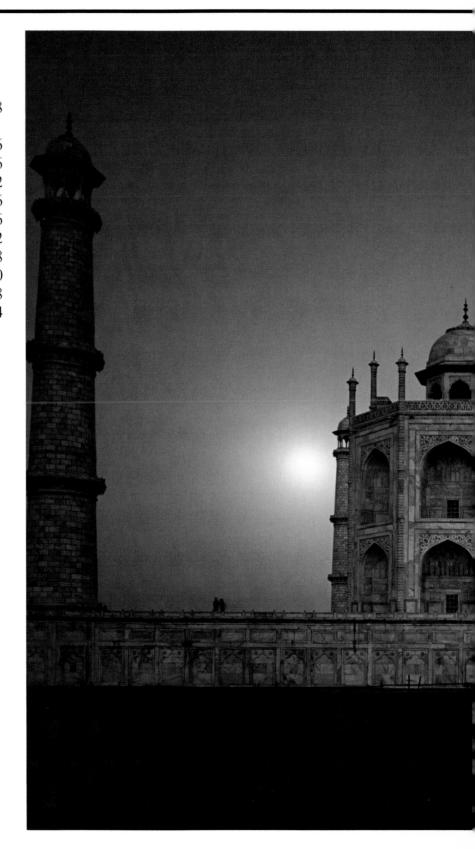

Automatic cameras

In its basic form, a camera is a lightlight box with a piece of film at one end and a lens at the other. The lens projects a sharp image of the subject onto the film. The film records it. Automatic cameras expand this basic theme with electronic wizardry that performs tasks in a fraction of the time the photographer could do them.

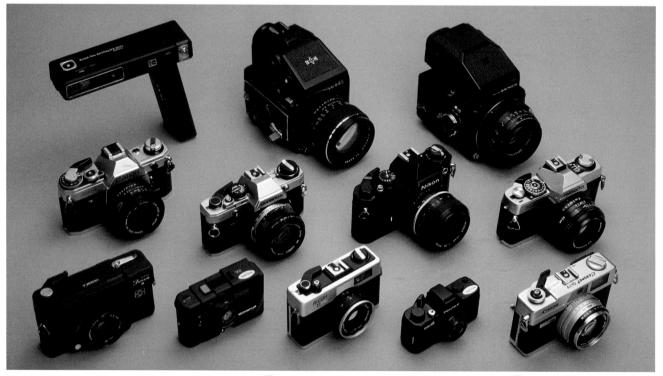

AUTOMATIC CAMERA FORMATS

Automatic cameras are available in several formats. The most popular and versatile are 35 mm cameras, with 110 cameras ranking a close second. The larger roll-film cameras cost more to buy and operate but offer a large negative, which is ideal for sharp enlargements.

35 mm Cameras

There are two basic types of 35 mm cameras. They are categorized by how their viewing systems work. The more versatile type is the 35 mm single-lens reflex camera.

The SLR viewing system uses a mirror and prism to intercept light passing through the lens and divert it up to the viewfinder where you see it form an image similar to the image the lens will make on film.

The second type of 35 mm camera has an optical viewing system separate from the lens. With it you do not see the image made by the lens. Some models use the viewfinder for both framing and focusing. They incorporate a rangefinding device coupled to the lens to permit rapid and accurate focusing. Those models are called rangefinder cameras. Other models have a viewfinder that is for framing only and is not linked to focusing. These models generally permit manual focusing by setting a distance scale or by reference to zone symbols. Several models provide automatic focusing. Automatic focus cameras transmit a signal toward the center of the picture field and automatically calculate the distance to whatever object or person reflects the signal, and then set the lens accordingly.

Because the SLR viewing system provides viewing and focusing of the image formed by the lens, SLR cameras can accept a great variety of interchangeable lenses and close-up accessories. The camera lets you see and judge what the film will record.

With a few exceptions, cameras with optical viewfinders do not ac-

cept interchangeable lenses. Although it is fairly easy to make an optical viewfinder that frames scenes accurately for a single lens, it is difficult and expensive to achieve accurate framing for several lenses with an optical viewfinder.

All conventional cameras are essentially variations on the basic theme shown here: a lighttight chamber with a lens at one end and a piece of film at the other.

Film for 35 mm cameras consists of a long strip wound on a spool in a lighttight magazine that is loaded into the camera. The film has edge perforations that are engaged by the camera's toothed drive wheels. Exposed film must be rewound into the magazine before removal from the camera.

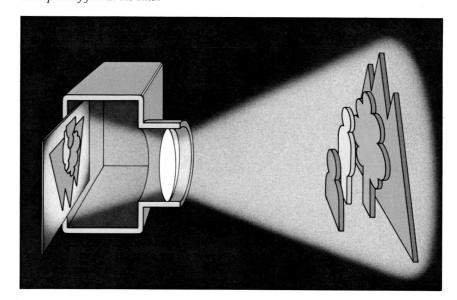

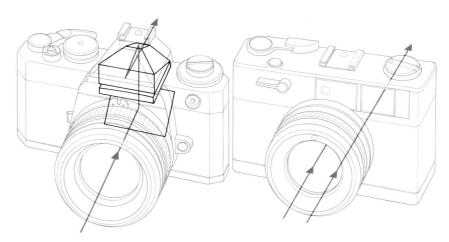

With an SLR camera, you compose and focus an image formed by the lens that will actually make the picture. The reflex mirror reflects the light from the lens to a ground-glass focusing screen, which you view through the finder eyepiece.

A direct optical viewfinder functions independently from the lens. The viewfinder is a small optical system through which you view the subject directly.

35 mm Single-Lens Reflex Cameras

Single-lens reflex cameras are tops in versatility. When you look into the finder of an SLR, you see an image formed by the lens that will make the picture. For most practical purposes, what you see is what you get.

Most SLR viewfinders contain several focusing devices. Commonly, the center of the focusing screen contains a split-image rangefinder inside a microprism field, and the balance of the screen is a matte ground glass. A split-image rangefinder does what its name says. It splits the image. Obvious discontinuity in a linear subject viewed through it results when the lens is not properly focused. When the lens is focused correctly, the line appears continuous, making the image whole. A microprism focusing field fractures unfocused images. When the image is in focus, the microprism texture diminishes, and you can clearly see the object on which you are focusing. When you focus with the matte ground glass area, a focused image will look sharp on the screen, while unfocused images will display varying degrees of unsharpness.

To give you a bright image for focusing, modern SLRs let you view with the lens aperture wide open. However, when you press the shutter release, the aperture closes down to

1000 900 250 250 00 15 15 4 4 2

A typical viewfinder display in an automatic 35 mm SLR shows you the lens aperture, shutter speed, and signals indicating underor overexposure conditions. The amount of information provided and the manner of displaying it vary from model to model.

the selected setting.

To permit you to preview what the image will be like at the smaller opening, most SLR cameras have a preview button or lever. When you actuate it, it closes the lens opening to the aperture that will actually be used to take the picture, and you can examine the scene for sharpness from front to back. This front-to-back

sharpness is called depth of field. Depth of field increases as the lens opening becomes smaller.

Automatic-exposure SLRs normally display exposure data in the viewfinder, indicating shutter speed, lens aperture, operating mode, overor underexposure warning and flash readiness, as applicable. Not all cameras incorporate all features.

To help you focus, many SLR cameras have a central split-image rangefinder, a microprism ring around the rangefinder,

and a ground glass filling the rest of the area. Compare the out-of-focus image, **top**, to the in-focus image, **bottom**.

erek Doeffing

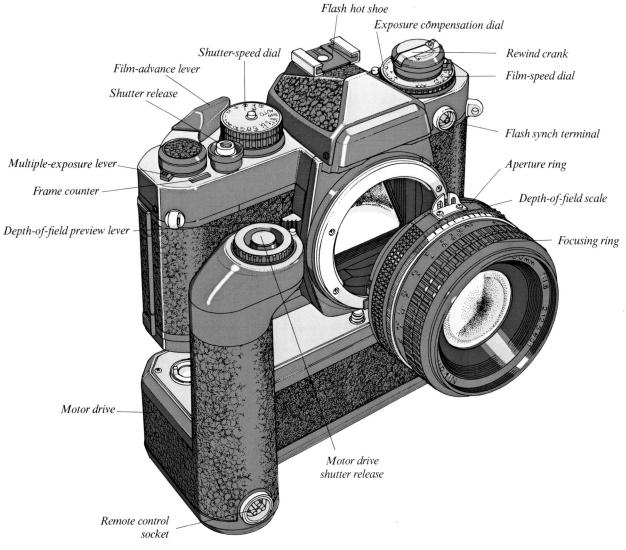

35 mm Single-Lens Reflex Camera

Nearly all SLR cameras permit interchanging lenses. Available optics range from extreme wideangle to ultra telephoto. In addition, most SLR cameras accept a variety of accessories that can adapt the camera to such specialized uses as close-up photography, photomicrography, astrophotography, and underwater photography. Many models accept accessory autowinders or motor drives, which advance the film and recock the shutter after each exposure. A few have built-in autowinders.

An SLR camera should be considered the nucleus of a photographic system rather than an isolated piece

of equipment. If you are about to buy one, study the overall system of accessories as well as the camera. If you have specialized photographic interests, or anticipate developing them, make sure the accessory system offers appropriate items. To some extent, differences in accessory systems may be more significant than differences between basic camera models.

Generally, 35 mm SLRs range from very compact, lightweight models just slightly larger than rangefinder cameras to larger, heavyduty models built to withstand years of professional use. All tend to be fast handling and easy to use. They can do everything cartridge-loading and rangefinder cameras can, and a great deal more, too, when fitted with various lenses and accessories.

A much wider variety of films is available for 35 mm cameras than for 110 and 126 cameras, including special-purpose materials for scientific applications. General-purpose, black-and-white films and color slide films are available in 20- or 36-exposure rolls. Kodacolor II and Kodacolor 400 Films are also available in 12-, 24-, and 36-exposure rolls.

35 mm Cameras with Optical Viewfinders

Except for the usual lack of lens interchangeability, these cameras may be as sophisticated as some 35 mm SLR cameras. Exposure systems are generally capable of handling a full range of daylight situations from bright sun to deep shadow. Shutter speeds typically extend from 1/8 to 1/500 second, although some models have shorter or longer ranges. The optical viewfinder through which the picture is composed usually has a bright frame delineating the picture area. In some models the frame line shifts position as the lens is focused to provide accurate framing even at close distances. This is called automatic parallax correction. It is a useful feature if you like to take tightly composed pictures at distances closer than 6 feet or so (approximately 2 metres). Simpler models have parallax correction marks in the viewfinder. Focusing may be manual by zone symbols, distance scale, or coupled rangefinder, or it may be automatic.

When viewing the subject through a coincidence-type optical rangefinder you see a double image when the lens is not focused on the subject. Focusing the lens merges the two images into one.

The more complex cameras in this category may display considerable exposure information in the view-finder, informing you as to the shutter speed and lens aperture about to be used, and warning of possible over- or underexposure. Some models also allow you to exercise full manual control, and a few have built-in flash units, a feature you don't find on SLR cameras. Some even have automatic film advance and motorized rewinding of the film.

The viewfinder display of this automatic 35 mm rangefinder camera uses a needle to indicate the shutter speed selected by the camera.

All cameras in this group benefit from the excellent enlargeability afforded by the comparatively large (24 x 36 mm) 35 mm format in contrast to the smaller 110 and 126 formats. The more compact models are nearly as small as many 110 cameras, and in fact are smaller than some of the larger 110 cameras. This is a sensible camera type for personal photography that does not require lens interchangeability or extremely close focusing. Photographically, these cameras do substantially the same job as the cartridge-loaders, but on a four-times larger film area.

Some cameras use a symbol focusing scale to indicate close, middle, and far distances.

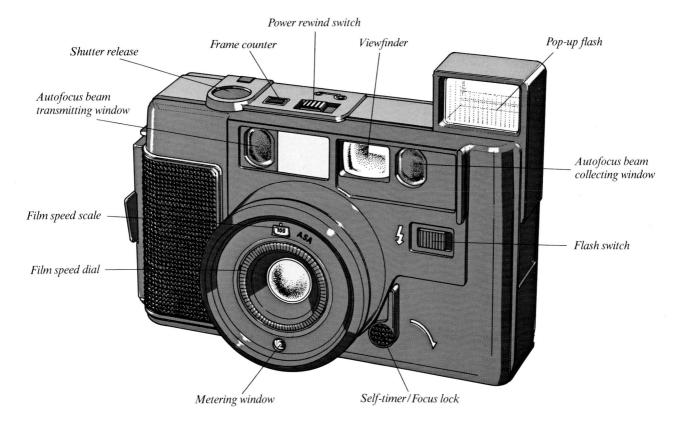

Automatic Focusing Camera

AUTOMATIC FOCUSING CAMERAS

Automatic focusing cameras work by determining the distance from the camera to the center of the picture area. In other words, they focus on whatever you see in the center of your viewfinder. If your subject should not be positioned centrally, it will probably be rendered out of focus.

Many auto-focus cameras have a focus lock. You use it by positioning your subject centrally and locking in the focus. You can then reframe the scene and obtain an in-focus picture. When using the focus lock, keep the same subject-to-camera distance as when you locked in the focus. If the subject should move substantially further or closer, the subject will appear out of focus.

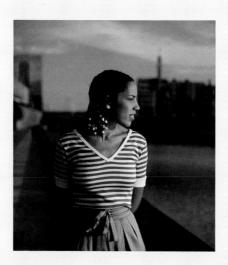

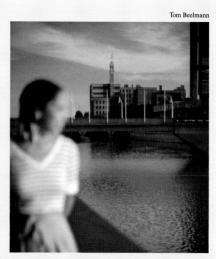

Drop-in film loading is a key attraction of 110 (shown) and 126 cartridge-loading cameras. The cartridges are shaped so they cannot be inserted into the camera incorrectly.

Cartridge-Loading 110 and 126 Cameras

The most distinctive feature of cartridge-loading cameras is ease of loading. A paper-backed strip of film sufficient for 12, 20, or 24 exposures is housed in a plastic cartridge that you simply drop into the camera. The shape of the cartridge prevents incorrect loading. The film remains in the cartridge at all times prior to processing. Notched according to a standard system, the film cartridge "tells" the camera the sensitivity of the film inside.

A simple, cartridge-loading 110 camera can serve well for most personal photography.

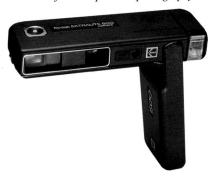

In the 110 format, individual negatives or transparencies measure 13 x 17 mm. Because the strip of film is narrow and the cartridge housing it is small, 110 cameras can be extremely compact. They range from non-adjustable models that are factory set to expose film properly outdoors on a bright day through automatic-exposure models that can accommodate wide lighting variations. Some have built-in electronic flash units and telephoto or close-up lenses.

The 126 format is 28 mm square, so 126-size cameras are slightly larger than 110 models. They cover a similarly broad spectrum of simple and complex cameras. However, no current 126 models can match the sophistication of the most advanced 110 cameras.

Cartridge-loading cameras use a variety of focusing systems. Fixed-focus models are set at one focus, which you can't adjust. They are factory set for the manufacturer's notion of a popular "snapshot" distance. They use a small lens opening that will provide a sharp picture from roughly 5 feet to infinity. Manual-focusing models are set by the user for the estimated distance to the subject.

Zone-focusing cameras are set for distance by matching an indicator to one of several symbols representing the type of photograph being made. Typical zone symbols include a stylized head and shoulders for close subjects, a standing figure or figures for medium distance and a mountain for distant scenes. A few cartridgeloading cameras have optical rangefinders for setting focus by visually merging double images into a single image in the viewfinder. Only a handful of 110 and 126 cameras are single-lens reflex (SLR) cameras, in which the focusing image is formed on a ground glass by the same lens that forms the image on film.

As a category, cartridge-loading cameras are at their best as no-fuss, point-and-shoot machines. They are capable of handling ordinary picture-taking demands competently and conveniently.

Roll-Film Cameras

Roll-film cameras most commonly use 120-size film rolls, which yield 16 exposures 1% x 2¼ inches (4.5 x 6 cm), 12 exposures 2¼ x 2¼ inches (6 x 6 cm), 10 exposures 2¼ x 2¾ inches (6 x 7 cm) or 8 exposures 2¼ x 3¾ inches (6 x 9 cm), depending on camera design. Although there are other sizes of roll film, 120 is currently the most popular for roll-film cameras in general use.

Automatic-exposure 120 cameras include both rangefinder and SLR types. They are significantly larger and heavier than cameras made for smaller formats, as are their interchangeable lenses and accessories. The major advantage of using a rollfilm camera is the large negative or transparency it produces. If you wish to make extremely large prints on a regular basis, you may feel the larger film format is desirable. Aside from yielding a larger film frame, this type of camera does nothing that cannot be done more easily with a 35 mm camera.

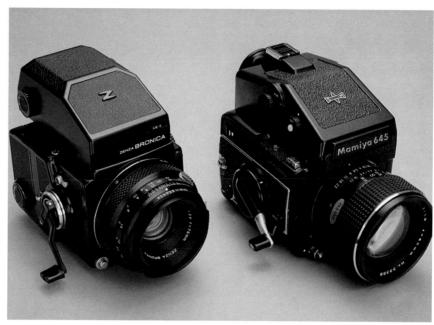

The major advantage of using a roll film camera is the large negative or transparency it produces. If you wish to make extremely large prints on a regular basis, you may feel the larger film format is desirable.

Roll films in 120 and other sizes consist of a strip of film backed by a longer strip of protective paper and wound on a flanged spool. The leading end of the film is taped to the paper backing so both will feed through the camera together.

Instant Picture Cameras

Automatic exposure, instant picture cameras offer ease of loading and rapid availability of album-sized color prints as major attractions. All focusing systems are represented; cartridge or pack loading prevails; and noninterchangeable lenses are the rule.

Most instant picture cameras are designed for extreme simplicity of operation and provide minimal scope for user intervention in the picturetaking process and minimal data about what the camera is doing for itself. A lighten-darken control usually allows making minor exposure corrections.

Generally, instant picture cameras fulfill the same functions as cartridge-loading 110 cameras, with greater bulk but without requiring you to wait for prints to come back from a photofinisher.

Instant picture cameras can deliver albumsize finished pictures on the spot, with no significant delay between taking the picture and seeing it. All popular instant picture cameras offer easy drop-in loading.

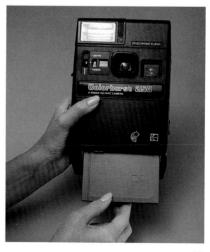

Exposure meters and exposure

A good exposure setting balances the amount of light reflected by the subject to the sensitivity of the film. Too much exposure, or overexposure, makes pictures look too light and burns out detail in lighter parts of a scene. Too little exposure, or underexposure, makes pictures look dark and causes loss of detail in darker areas. Although you know the film sensitivity, you do not know the amount of light reflected by the subject. An exposure meter helps you or the camera to balance the amount of light entering the camera to the sensitivity of the film.

An overexposed picture has burned-out bright areas with too little visible detail and too-light darker areas with too much visible detail A properly exposed photograph presents a generally familiar rendition of the subject, with a natural-looking distribution of light and dark tones.

An underexposed picture reveals too much detail and texture in very bright areas, and too little detail in darker areas, which tend to merge into black masses.

Correctly Exposed

Underexposed

CAMERA EXPOSURE METERS

To produce a satisfactory picture, the film in your camera must be exposed to enough image-forming light to record detail over a range of light and dark subject tones. You can measure the amount of light with an exposure meter. A camera's exposure meter consists of a light-sensitive element that responds predictably to the different light levels to which it is exposed. An associated electronic or electromechanical system relates the light intensity to the film sensitivity and tells you or the camera the shutter speed and lens aperture required to achieve proper exposure.

The light-sensitive element, or photocell, may be positioned on the

In a non-SLR camera, the photocell is often mounted on the front of the lens.

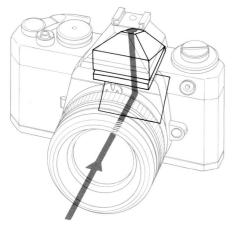

In an SLR camera with a through-the-lens meter, the photocell measures the intensity of light passing through the lens.

camera to read a view that corresponds to that of the lens. With SLR cameras, the cell is usually mounted inside the camera where it can respond to light passing through the lens. The more versatile automatic cameras, including automatic 35 mm SLRs, tell you the exposure settings the meter is specifying. And many allow you to modify or ignore those settings as you wish.

Batteries are extremely important in automatic cameras, because they power most automatic exposure systems. Without battery power, you lose metering ability. Many automatic SLRs shut down when batteries fail, or offer you a single emergency shutter speed. It is then up to you to estimate, without the aid of the meter, the appropriate exposure. With a few automatic cameras you can switch over to a manual mode and use a full range of shutter speeds when batteries fail. However, it is still up to you to estimate exposure without the meter. Always carry a spare set of batteries for your camera.

METER READING AREA

To determine an accurate exposure of the subject, the meter cell should read light reflected from a tonally significant area of the subject. A reading from an irrelevant area may cause over- or underexposure, especially when the subject is lighter or darker than other parts of the picture. The area the meter reads can vary considerably from one camera design to another. Meters are commonly classed as averaging, spot-reading, or center-weighted.

The owner's manual for your camera indicates the area your metering system reads. Keep the metering area in mind whenever you photograph a scene that is not fairly uniform in brightness. Make sure the part of the scene on which you wish to base exposure falls in the area of the meter's maximum sensitivity. If nec-

essary, reframe the scene until the important subject area corresponds to the metering area. Then make a reading and hold it or lock it into the camera manually before reframing the scene for best composition. You know whether or not the meter is reading what it should be reading. The meter cannot tell.

An averaging meter gives equal weight to all parts of the field seen in the viewfinder. It averages the various areas of light and dark into an estimate of the required exposure.

A spot-reading meter measures only a small portion of the illumination from a scene. It is usually confined to a small central circle or rectangle as seen through the viewfinder.

A center-weighted meter emphasizes the central portion of the scene but also measures illumination in the outer portion. Darker shading represents less sensitivity; lighter shading indicates more sensitivity.

CONTROLLING EXPOSURE

Together, the lens aperture and shutter regulate the amount of light reaching the film. The meter determines the aperture and shutter settings required for proper exposure. The aperture regulates the flow of incoming light. The shutter regulates how long the flow lasts. To maintain proper exposure at a given light level, any change in lens aperture requires a complementary change in shutter speed and vice versa.

Neil Montanus

THE SHUTTER

The shutter is a timing device connected to a mechanism for uncovering and covering the film. In automatic cameras that adjust exposure by changing the shutter speed, the shutter is usually continuously variable, providing stepless speed variation throughout its range. In cameras with manually adjustable shutters, speeds are generally presented in a progression in which each faster speed represents one-half the time of the preceding speed. A typical shutter speed range in seconds for an SLR camera is 1, 1/2, 1/4, 1/8, 1/15, 1/30, 1/60, 1/125, 1/250, 1/500, and 1/1000 second.

Some shutters provide timed speeds longer than 1 second and shorter than 1/1000 second. The B shutter setting is for taking long exposures. When set at B, the shutter will stay open as long as you depress the shutter release button. Each full step up or down the range is a one-stop exposure change. The term "stop" refers to a doubling or halving of exposure. It is more properly associated with changes in lens aperture, but is commonly applied to changes in shutter speed as well.

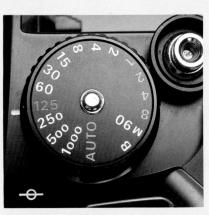

In a typical progression of shutter speeds, each faster speed is half as long as the preceding speed.

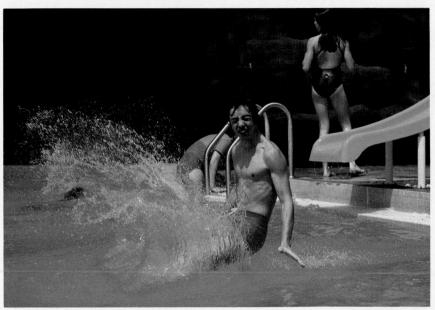

A high shutter speed, such as 1/1000 second, freezes the motion of moving subjects. A slow shutter speed, such as 1/30 second, blurs the motion of moving subjects

and may show blur on unmoving subjects from camera movement. Sometimes blurred photos are more interesting than stopaction shots.

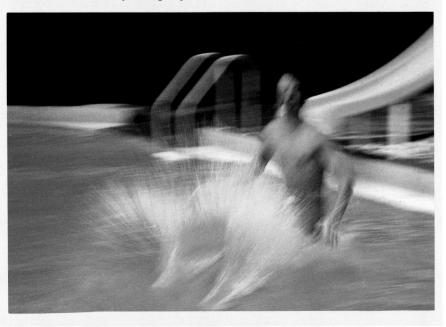

THE APERTURE

The aperture is an adjustable opening formed by an iris-like diaphragm in the lens barrel. A wide aperture passes lots of light; a narrow aperture passes little light. Cameras that set the aperture automatically have a continuous range of aperture sizes. In cameras requiring you to set the aperture, the aperture control ring on the lens barrel is clickstopped at full- and usually half-stop intervals. The full-stop settings are identified by f-numbers. They progress as follows: f/1.4, f/2, f/2.8, f/4, f/5.6, f/8, f/11, f/16, and often f/22. A low f-number such as f/2 stands for a large opening. A high f-number such as f/16stands for a small opening. Each successively smaller number (larger opening) lets in twice as much light as the adjacent larger number (smaller opening). For instance, f/5.6 lets in twice as much light as f/8. Often the largest aperture marked on a lens is an intermediate value such as f/1.7 or f/3.5.

The lens diaphragm can be adjusted to regulate the amount of light passing through the lens. Specific settings are identified by f-numbers. Small f-numbers are associated with large lens apertures and large f-numbers are associated with small lens apertures.

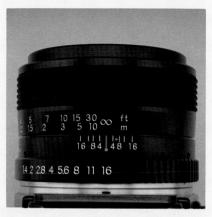

By rotating the aperture control ring you determine the size of the aperture on an aperture-priority camera.

f/4

f/5.6

f/8

f/11

f/16

Aperture size helps control the extent of sharpness in a picture. At wide apertures, a lens yields very little sharpness in depth, or depth of field. Only the subject plane on which you have focused is likely to be recorded crisply. Objects significantly closer to or farther from the camera will look noticeably less sharp. At small apertures, you will have more depth of field, so objects considerably ahead of and behind the point of focus may be rendered sharply. Depth-of-field requirements, as well as exposure control, should be considered when selecting the lens aperture.

At a wide aperture, such as f/2, only the subject plane on which you have focused will be rendered sharply.

At a small aperture, such as f/16, depth of field increases. Details in the foreground and background are better defined.

Many combinations of aperture and shutter speed let in the same amount of light. In selecting shutter speed and aperture, consider the need to stop action, **left**, and to show great depth of field, **right**.

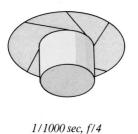

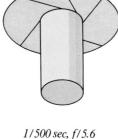

1/250 sec, f/8

CHANGING BOTH SHUTTER SPEED AND APERTURE

In a given situation, correct exposure requires exposing the film to a specific quantity of light. That quantity can be obtained with a variety of shutter speed and aperture setting combinations. It's like filling a bucket with a trickle of water for a long time or a gush of water for a short time. For example, the following camera settings let in the same quantity of light:

1/1000 second at *f*/4 1/500 second at *f*/5.6 1/250 second at *f*/8 1/125 second at *f*/11

When you set the shutter speed or lens aperture, determine if the setting for the shutter speed or the aperture is more important. If you are trying to freeze a downhill skier, you will need a fast shutter speed, such as 1/1000 second. If you are trying to get front to back sharpness of a flower garden, you will need a small aperture, such as f/16. Sometimes neither shutter speed nor aperture will be extremely important, and you can use intermediate settings such as 1/125 second at f/8. Remember, the shutter speed and aperture work in concert. Change one, and you or the camera must change the other.

1/125 sec, f/11

SPECIAL EXPOSURE CONTROLS

Most automatic cameras let you override the camera's exposure system to avoid exposure mistakes caused by unusual lighting or to achieve special effects with under- or

overexposure. An automatic camera usually has one of the following controls: exposure compensation control, backlight button, or exposure-hold control. Some automatic

cameras offer a manual mode that can be used to vary exposure, and nearly all offer ISO(ASA) film speed dials that, if necessary, can also be manipulated to vary exposure.

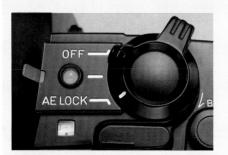

EXPOSURE-HOLD CONTROL

The exposure-hold control is a button or lever that locks the exposure system at the setting indicated the moment the control is actuated.

With the exposure-hold control, you can approach the important subject in a scene, take a close-up exposure reading, lock in that setting, and then back off to take the picture. You can also manipulate exposure by locking in an exposure with the camera aimed at a bright or dark area, and then reframing the scene to take the picture. If your camera has an exposure-hold control, check the owner's manual regarding operating procedure. If the control isn't self-canceling, be sure to turn it off the moment you finish using it. You don't want it working when it shouldn't be.

BACKLIGHT BUTTON

The backlight button works while the automatic exposure system continues to operate. The backlight button is mounted on the front of the camera. Usually you must hold it in while making an exposure. It typically increases exposure by $1\frac{1}{2}$ stops. It cannot decrease exposure.

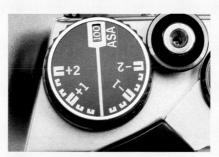

EXPOSURE COMPENSATION CONTROL

The exposure compensation control is typically a dial atop the camera that you rotate to gain up to ± 2 stops exposure variation. The automatic exposure system continues to operate, protecting you from unnoticed changes in light intensity. Be sure to reset the dial to normal when you are finished using it so it doesn't influence exposure when you don't want it to.

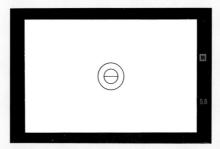

MANUAL OPERATING MODE

Many cameras with automatic exposure control also permit manual exposure control, with or without benefit of the camera's built-in meter. With some models, setting the camera to manual shuts down the meter. With these cameras, take exposure readings in the auto-exposure mode, note the suggested settings, then switch to manual and set the exposure as you wish, with the guidance of the previous readings. Other models are more convenient in that the metering system continues to provide exposure information in the manual mode, although you must transfer the meter recommendations to the camera controls yourself.

FILM-SPEED SETTING

If your camera doesn't have an exposure-compensation device, you can alter the automatic exposure setting with the film-speed dial. To decrease exposure by a stop, set the ISO(ASA) dial to double the ISO(ASA) rating of the film. To increase exposure by a stop, set the ISO(ASA) dial to half the ISO(ASA) rating of the film you are using. With a film actually rated at ISO(ASA) 200 (top picture), you can increase exposure 1 stop by changing the film-speed setting to 100 (second picture) or decrease exposure 1 stop by changing the film-speed dial to 400. Reset the dial to the correct film speed when you are finished.

WHEN TO VARY EXPOSURE

Some people think automatic exposure means perfect exposure. That's not the case. Automatic exposure is not perfect. It is designed to provide good exposure for scenes of average brightness and reflectance, which, fortunately, most scenes have. But not all scenes have average bright-

ness and reflectance. Your concern is with them. To obtain correct exposure of such scenes you must override the automatic exposure. Usually you must shift the exposure just the opposite of what you might expect. For example, you might think the brilliance of a sunlit field of snow would need less exposure than recom-

mended by the camera meter. Instead, it requires more. More is needed because the meter tries to render that brilliant scene as average, making white snow gray. The four examples below show typical scenes that result in incorrect exposure and tell how to obtain correct exposure.

1. The meter tries to render highly reflective or nonreflective scenes as average reflectance, making highly reflective scenes such as snowfields too dark and nonreflective scenes, such as a coal bin, too light. For highly reflective subjects, increase exposure by 1 or 2 stops. For nonreflective subjects, decrease exposure by 1 stop.

2. With scenes containing both large bright areas and large dark areas, the meter often reads too much of one area, to the detriment of the other. The solution is to take readings of both the bright and dark areas, and then use a setting in between these two extremes, or key the setting to the most important part of the scene.

3. With scenes containing a background that is much brighter or darker than the subject, the subject is often incorrectly exposed. The solution is to take a close-up meter reading of the subject and use the setting indicated.

4. With the sun or a bright expanse of sky shining into the lens, the meter is overwhelmed by light and underexposes any darker subjects. This most often happens in pictures of people where the subject stands against a bright sky and ends up a silhouette. When possible, determine exposure by taking a close-up reading. If you can't take a close-up reading, increase the recommended exposure by 1½ stops.

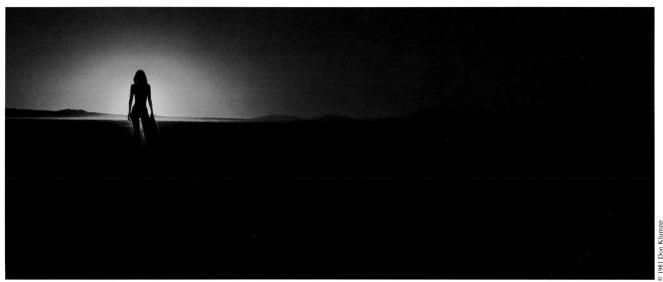

CREATIVE EXPOSURE

Not all subjects look best when shown in a "correct" exposure. Underexposure or overexposure can sometimes make a subject look better. This is especially true of contrasty scenes, where underexposure can produce a silhouette against the sky or dramatize a highlight against a dark surrounding. Experiment when you think the scene might look better at an exposure other than normal.

Had this picture been given normal exposure it would have appeared as a typical beach scene. By underexposing several stops, the photographer created a dramatic picture.

BRACKETING EXPOSURE

Any time the lighting conditions are tricky, as in the examples on the opposite page, and you want to be absolutely sure of getting a good picture, you should bracket exposures.

Bracketing consists of making one exposure at meter-recommended settings, then making additional exposures at settings over and under the first. Bracketing usually assures an acceptable exposure when faced with contrasty scenes or unusual lighting conditions. Bracketing is most useful

Normal

with slide films because they have less exposure latitude than negative films, which the photofinisher can manipulate during printing. With negative films, bracket, but overexpose an extra stop or two when in doubt. Bracketing is usually done in full stops for a range of plus and minus 1 or 2 stops. For more subtle variations, use half stops over the bracketing range. In highly unfamiliar situations, bracketing might span a wider range. If the meter-recommended exposure is off base, one of the bracketed shots will probably be on target.

+1 stop

To bracket, take additional exposures at a full stop over and a full stop under the normal exposure.

−1 stop

Derek Doeffing

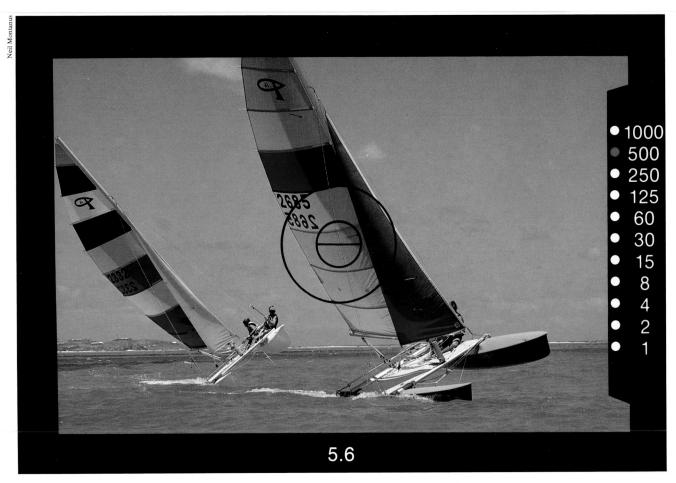

TYPES OF EXPOSURE AUTOMATION

Automatic cameras differ in the degree and type of exposure automation they provide. Some cameras set both the shutter speed and the aperture. With others you set the aperture and the camera sets the shutter speed. And with still other cameras, you set the shutter speed and the camera sets the aperture. Some automatic cameras even offer several or all of the above options.

Aperture-Priority Automation

With aperture-priority automatic cameras, you set the aperture and the camera sets the shutter speed. Any time you change the aperture or the light level changes, the shutter speed also changes. A shutter-speed indicator is usually provided in the view-finder. Monitor it to make sure the shutter speed is what you want.

Sometimes the camera cannot set a shutter speed fast or slow enough to match the aperture you've chosen. When that happens, change apertures until the shutter speed falls within the camera's range. To obtain the fastest possible shutter speed in dim light, set the lens aperture to its widest setting.

When photographing action with an aperture-priority camera, keep an eye on the shutter-speed indicator. Make sure the meter doesn't set a speed too slow for the action. If that happens, open the lens aperture to restore an adequate shutter speed. When photographing action, **above**, with an aperture-priority camera, check that the shutter speed will stop the action. If the speed drops too low, open the aperture as necessary until the camera sets a more suitable faster shutter speed.

With a shutter-priority camera, check the aperture readout, above right, before shooting to make sure you will have enough depth of field. If the aperture is too large, lower the shutter speed until the camera sets a more appropriate lens opening.

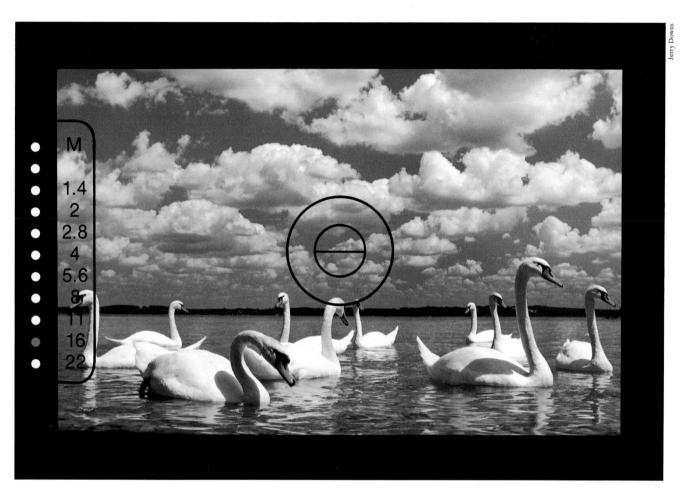

Shutter-Priority Automation

With shutter-priority cameras, you set the shutter speed and the camera sets the aperture. Any time you change the shutter speed or the light level changes, the aperture changes. A readout visible in the viewfinder indicates the aperture the camera is setting. If the camera is unable to set a lens aperture small enough to achieve proper exposure, select progressively faster shutter speeds until the required aperture drops into the available range. If the camera cannot set a lens aperture large enough for proper exposure, select slower shutter speeds until the needed aperture corresponds to one that is available.

With a shutter-priority camera, keep track of the aperture the camera is setting. Make sure it provides the depth of field you want.

Programmed Automation

Cameras with programmed automation respond to changes in light level by adjusting both the shutter speed and the lens aperture, either simultaneously or alternately.

Most programmed automation is based on compromise. The program tries to provide reasonable depth of field and a shutter speed to stop moderate action. If you use a camera with programmed automation for action shots or low-light photography, use a high-speed film to help keep shutter speeds from dipping too low.

Multi-Mode Automation

As no one approach to exposure automation is ideal in all circumstances, several 35 mm SLRs offer a choice of operating modes to suit specific situations. A selector switch

allows you to choose from shutterpriority, aperture-priority, manual exposure control, or programmed automation. A few cameras also permit switching between spot and average metering. Not all multimode cameras provide all options, but the choice between aperture and shutter priority is standard for multimode machines.

Use shutter-priority operation for action photography, in which precise control of shutter speed is desirable. Use aperture-priority operation when it is important to control depth of field carefully. Use programmed automation for casual photography when you do not want to be bothered making any settings at all. And use the manual mode when you feel you will be able to do a better job of determining exposure than the automatic system can.

Lenses

The number and variety of lenses available for SLR cameras is astounding. There are lenses for dim light, for close-ups, for long distances, lenses for portraiture and lenses for architecture. There are zoom lenses, wide-angle lenses, telephoto lenses, and normal lenses. Whatever the design, whatever the cost, all lenses share one common purpose: to form a desirable image of the subject on film.

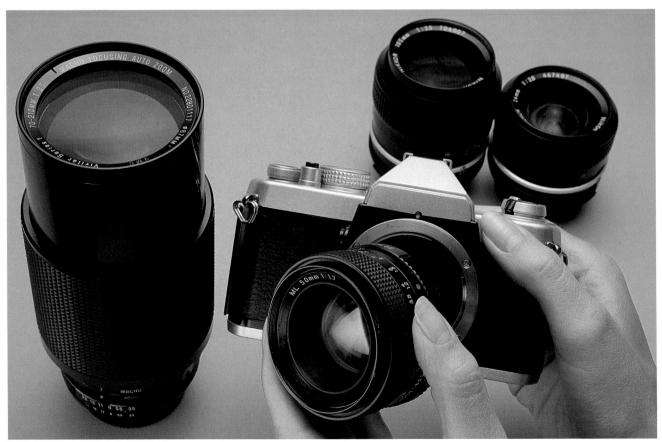

LENSES

The great advantage of SLR cameras is that they accept a wide variety of lenses and most non-SLR cameras don't. Lenses can be a creative factor. With a long telephoto lens you can render a setting sun enormous. With a wide-angle lens you can render it small and distant. Some lenses will suit your photographic style or interests better than others. Specialists in sports photography use telephoto lenses. Specialists in flower photography use macro lenses. As you become more familiar in photographing certain subjects, you'll learn if a specific lens will benefit you or not.

Lens Focal Length

Lenses are classified by their focal lengths. The focal length of a lens is the distance from its optical center to the film when the lens is focused at infinity, which for practical purposes is a distant object. Focal length is usually expressed in millimetres.

Normal lenses have a focal length approximately equal to the diagonal of the film format with which they are used. The diagonal of a 35 mm frame is about 43 mm. Normal lenses for 35 mm cameras generally have focal lengths anywhere from 40 to 58 mm. The diagonal of a 110 frame is roughly 21 mm, with normal lenses for that format having focal lengths of about 25 mm.

For a given film format, a lens with a focal length significantly shorter than a lens of normal length is called a wide-angle lens. Any lens for a given format with a focal length longer than a normal lens is considered a telephoto lens.

The focal length of a normal lens approximates the diagonal of the film format. The diagonal of a 35 mm frame is approximately 43 mm.

Lens Aperture

The maximum aperture of a lens and its focal length provide important information about the lens. The focal length tells you whether the lens is a wide-angle, normal, or telephoto. The maximum aperture tells you about the light-gathering ability of the lens. The larger the maximum aperture (the lower the numerical value of the f-number), the better suited the lens is for use in dim light. A lens set at f/1.4 admits eight times the light that a lens set at f/4 lets in and can easily be used in dim light.

The focal length of a normal camera lens is the distance from the approximate center of the lens to the film plane when the lens is focused on infinity. With telephoto lenses, the focal length is often the distance from the film plane to a point in front of the lens.

Although lenses with unusually large maximum apertures are ideal for existing-lighting photography, they cost more than lenses with average-size maximum apertures. A normal lens with a maximum aperture of f/1.8 or f/2 will suffice for most photography.

WIDE-ANGLE LENSES

A wide-angle lens includes more of the scene than a normal lens. This makes wide-angle lenses useful for photographing panoramas and interiors.

The most popular wide-angle lenses for 35 mm cameras have focal lengths from 28 mm to 35 mm. Their fields of view are sufficiently wider than normal lenses to create a wide-angle look but are not so extreme as to be difficult to handle. Wide-angle lenses of shorter focal length, such as 18 mm, 21 mm, or 24 mm lenses, demand considerable care in camera handling. Minor discrepancies in leveling the camera create disproportionately out-of-kilter perspective effects.

The most common type of lens is called a normal lens. It produces an image with a field and perspective approximating normal vision. Most cameras come equipped with normal lenses.

The popularity of normal lenses stems partly from the pleasant familiarity of the views they produce and partly from their ease of use. They take in a wide enough field to capture sweeping scenes at a distance, yet they can also isolate relatively small areas when you move in close. They are easy to hold steady at relatively slow shutter speeds, too.

TELEPHOTO LENSES

Telephoto lenses see a narrower field of view than normal lenses. They are, in effect, telescopic. Telephoto lenses allow you to approach your subject optically instead of physically.

The most widely used telephotos for 35 mm cameras have moderate focal lengths in the range from about 85 to 200 mm. Image magnification is great enough to tighten composition attractively but not so great as to impose too many limitations. Lenses of 200 mm focal length and longer require faster shutter speeds because they magnify camera and subject motion along with the image. Compared with the moderate telephotos, they are large and heavy. For best results, use a tripod or other firm camera support if you use a lens of 200 mm or longer at shutter speeds below 1/250 second.

28 mm lens

50 mm lens

300 mm lens

Patrick Walmsley

ZOOM LENSES

The versatility of zoom lenses has often led to their use in place of telephotos. Instead of having a fixed focal length, a zoom lens has a continuously variable range of focal lengths. One zoom lens can replace two or more conventional fixed-focal-length lenses. Zooms are available with focal-length ranges covering nearly every conceivable portion of the focal-length spectrum. For 35 mm photography, one of the more popular zoom ranges is from approximately 80 to 200 mm, which provides about all the telephoto coverage a nonspecialized photographer needs. Some zooms have a focal-length range from wide-angle to telephoto. A 35 to 140 mm zoom is an example. Other zooms have only a wide-angle or telephoto range.

Aside from the convenience of carrying one lens in place of several, photographers like zoom lenses because they permit framing the image precisely without changing lenses or shooting distance. Many zoom telephotos also permit taking close-ups without any special attachments. When you zoom from a short focal length to a longer one, be sure the shutter speed is appropriate to the longer focal length.

With a zoom lens you can stand in one place and change the image size by changing the focal length of the lens.

MACRO LENSES

Macro lenses are designed to provide superior performance for close-up photography. Most are also capable of focusing continuously to infinity for general-purpose picture-taking. Macro lenses are usually of normal or moderate-telephoto focal lengths. The focusing mount of a macro lens customarily permits focusing close enough to make an image on film that is half the size of the actual subject. The close-focusing ability of a lens is commonly described by a ratio such as 1:2 or 1:4, which indicates the ability to record a small subject ½ or ¼ life size, respectively. Many macro lenses can also be used with accessory extension tubes that permit making images in the range between half life size and life size.

If you intend doing much close-up photography, a good macro lens is a wise investment. It is the easiest approach to close-up work and,

depending on the focal length, can double as a normal lens or a short telephoto.

When taking close-ups, focus precisely on the most important subject area because depth of field is extremely limited. If possible, use a tripod to prevent camera movement. When stopping motion is not a factor, use an aperture small enough to provide as much depth of field as the picture requires, even if you have to use a fairly slow shutter speed. Whenever motion stopping and sharpness in depth are both needed, use fast film or an electronic flash unit.

Macro lenses are highly corrected for photography at close distances and focus close enough to let you make large images of small subjects without additional accessories.

DEPTH OF FIELD

Depth of field is the area in a scene from near to far that appears sharp in the picture. Too little depth of field may leave important subject areas poorly defined or completely unrecognizable. Too much depth of field can create visual chaos and detract from the subject by burying it in an avalanche of irrelevant detail. You can control depth of field by various means

The aperture offers the readiest control of depth of field. With a given focal length at a fixed distance, depth of field increases as the lens aperture decreases in size. Depth of field decreases as the aperture increases in size. For instance, an aperture of f/22 gives much more depth of field than an aperture of f/1.8.

The larger the image size on film, the less depth of field you get at a given lens aperture. This is true whether you increase the image size by moving closer to the subject with the same lens, or maintain the distance and switch to a lens of longer focal length. The reverse is also true: decreasing the image size on film increases the depth of field at a given aperture.

With most SLR cameras, you can judge depth of field visually on the focusing screen by closing the lens to the actual aperture that will be used to take the picture. This is usually done with a preview button or lever. However, when you use the preview button at a small aperture, the focusing image may appear too dark to judge depth of field.

If your camera doesn't permit previewing depth of field, the lens may be equipped with a depth-of-field scale that shows the limits of the

sharp zone. The scale is usually located on the lens barrel and consists of pairs of marks identified with f-numbers on the lens. One mark in each pair is to the left of the central focusing index; the other is to the right of it. Adjacent to the depth-of-field scale is the distance scale, often calibrated both in feet and metres.

When you focus the lens, the distance scale moves relative to the focusing index and the depth-of-field scale. The focusing index shows the distance to the subject on which you have focused the camera. To determine depth of field, find the marks on the depth-of-field scale that correspond to the aperture you wish to use. The portion of the distance scale lying between the marks represents the depth of field at that aperture and focusing distance.

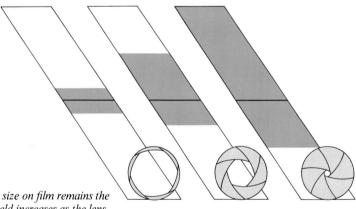

When the image size on film remains the same, depth of field increases as the lens aperture decreases. Here the first picture was made at f/2.8 and shows little depth of field. The second was made at f/8 and shows more depth of field. The third was made at f/16 and shows great depth of field.

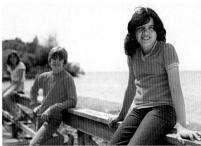

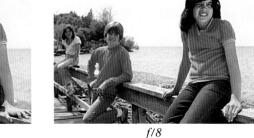

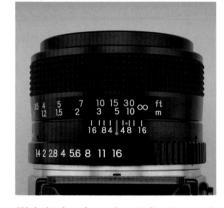

With this lens focused on 15 feet (5 m) and the aperture set to f/16, the depth-of-field scale indicates a zone of sharpness extending from about 9 feet (3 m) to infinity. The scale provides a quick check on depth of field at any aperture and focusing distance.

f/16

f/2.8

USING THE DEPTH-OF-FIELD SCALE

The depth-of-field scale can guide you to the most efficient use of depth of field. For example, this scale can indicate how to show a flower bed sharp from front to back using the largest aperture possible. Here's how to do it.

First focus on the farthest flowers. Note the indicated distance on the distance scale. Here it is 10 feet (3 m).

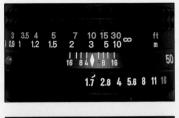

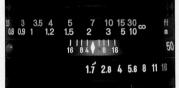

Focus on the nearest flowers and note their distance. Here it is 7 feet (2 m).

Adjust the focusing collar until you find the aperture marks for the largest aperture that completely encloses the near and far distances of 7 and 10 feet (2 and 3 m).

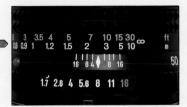

As shown here that aperture is f/8. Set the aperture ring to f/8. You have now focused the lens for overall sharpness of the flower bed. You have also chosen the largest aperture giving the required depth of field.

PERSPECTIVE

Perspective refers to the way a threedimensional subject looks when shown in two dimensions. In photography, perspective is a function of distance from the subject. Changing the camera-to-subject distance changes the perspective.

We tend to be unaware of perspective unless it is extreme. The most common forms of extreme perspective result from photographing at very close distances with wide-angle lenses and from long distances with telephoto lenses. In the first instance, objects or parts of the subject close to the lens appear disproportionately

Perspective exaggeration occurs when a wide-angle or normal lens is used at too close a distance. In this case, an 18 mm wide-angle lens was used.

large compared to those slightly farther away. In the second case, objects known to be in different planes appear squeezed together.

These effects are not inherently good or bad. You can use them deliberately when they will strengthen a picture, or you can avoid them when they might weaken the image.

With a telephoto lens, distances between subjects are compressed, making them seem much closer than they actually are. The exaggerated perspective is a function of the camera-to-subject distance.

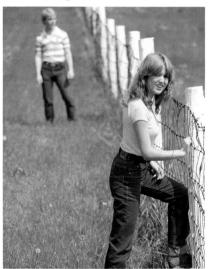

Within broad limits, perspective is largely a matter of taste. However, when making portraits, avoid extremes. Moving too close with a normal or wide-angle lens exaggerates facial features unpleasantly. And shooting from afar with a lens much longer than 135 mm tends to flatten the face.

In this shot with a normal lens, notice how the distance between the girl and boy seems much greater than in the shot taken with a telephoto lens.

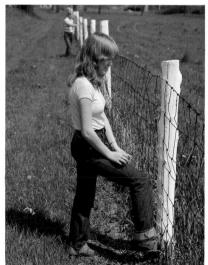

Derek Doeffir

Camera handling

All that automation in your camera will be for naught if you don't follow a few basic procedures when handling your camera. The procedures are simple. They are also important. A misset ISO(ASA) dial can cause incorrect exposure of all your pictures. A shakily held camera can blur pictures. Practice camera-handling procedures until they become second nature.

For additional steadiness in holding the camera, keep your arms tucked in against your torso. With a 35 mm SLR camera, grasp the lens so you can focus without changing your grip. When holding a 35 mm camera vertically, you can keep your right hand high or low. Choose whichever position is more comfortable for you.

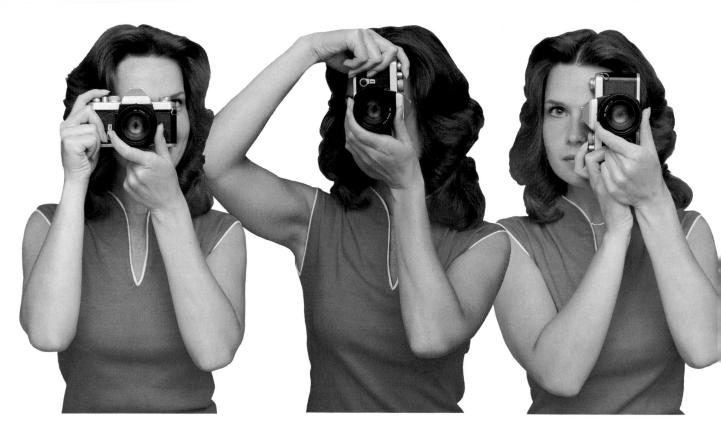

HOLD THE CAMERA STEADY

To make sharp pictures, you must hold the camera steady during exposures. Stand with your feet about 18 to 24 inches (45 to 60 cm) apart to form a broad base, and hold the camera body firmly against your face.

For additional bracing, tuck your arms against your torso. Hand placement on the camera varies with the camera design, so consult the owner's manual for recommendations.

Since 110 and 35 mm cameras make rectangular pictures, learn to hold these cameras in horizontal and vertical positions. Depending on your size and build, you may find it easier to hold a 35 mm camera vertically with the right hand high and index finger on the shutter release, or conversely, with the right hand low and the right thumb or index finger on the release. Use whichever hold is more comfortable.

When using a telephoto lens or a slow shutter speed, minimize camera motion by leaning against a stable

When using heavy lenses, place your left hand beneath the camera body like a shelf, with your fingers gripping the lens barrel. With many lenses, you can focus with your fingertips without shifting your hand.

structure nearby for additional support. Lean against a wall or a tree or brace your arms on a table or the back of a chair.

PRESS THE SHUTTER GENTLY

A jab at the shutter release can negate steady camera holding. To release the shutter with minimal camera movement, take a deep breath, exhale until you feel comfortable, then hold your breath. Gently increase pressure on the shutter release until it trips.

USE A FAST ENOUGH SHUTTER SPEED

When photographing stationary subjects with a normal lens, use a shutter speed of 1/60 second or faster. Faster shutter speeds counteract slight camera movement. Use them when depth of field is relatively unimportant. Shutter speeds of 1/125 or 1/250 second are good choices. The slowest shutter speed for handholding any lens is 1 over the focal length of the lens. For example, a 135 mm lens should not be handheld at less than 1/125 second (the nearest marked shutter speed to the 135 mm focal length of the lens).

BEFORE USING THE CAMERA

Check for film in the camera

Does your camera have film in it? Here's one sure way to tell. Gently turn the rewind knob as though rewinding, but without depressing the rewind button. If the knob resists turning, film is in the camera.

Set the compensation control at neutral

Don't start taking pictures without verifying that the compensation control is at zero compensation. Some compensation controls share the position with an ISO(ASA) dial and either one can be misset accidentally.

Set the film speed

Whenever you load film, set the film speed on the ISO(ASA) dial immediately. If your camera back has a memo holder, stick the flap from the film box in it. Then you can double check that the correct film speed is set.

Loading film into a 35 mm camera

A short strip of film called a leader extends from a 35 mm magazine. You must engage the leader in a slotted take-up spool in the camera. Advance the film with the film advance lever or autowinder until the toothed drive wheels engage both the top and bottom rows of perforations. Close the camera back. Advance the film until the frame counter shows you are ready to take the first picture. When the last frame on the film is exposed, rewind the film into the magazine before opening the camera back. A few 35 mm cameras have quickloading features. Consult your owner's manual for details.

CAMERA CARE

Keep Your Camera Clean

Clean cameras work better and last longer than dirty ones. Although a full-scale internal camera cleaning is a job for a skilled repair technician, there's quite a lot you can do simply and easily to keep your camera in top shape.

Cleaning Materials

These are indispensable. They provide the only safe way for cleaning the camera and lens. Lens brushes are available that are styled like small paint brushes or designed as retractable models in lipstick-like cases. The former are handy for cleaning the camera body. The latter should be kept in the camera bag for emergency lens wiping. Any brush you use on a lens should be used for that purpose only. Do not touch the tip of the brush with your fingers. Oil from your skin will collect on it and eventually be deposited on the lens.

Clean the Lens

A clean lens makes sharper pictures than a dirty one. Before each day's shooting, check front and rear lens surfaces. Any particles on a lens surface should be blown away. Don't wipe a lens that has sand or dust on the surface because gritty particles can cause scratches. If a particle won't blow off, roll a sheet of KODAK Lens Cleaning Paper into a tube, tear it in half and use a torn end to nudge off the speck.

If you get a fingerprint on a lens surface, first blow the surface free of particles. Then wad a piece of lens cleaning paper and moisten it with Kodak Lens Cleaner. Use the moistened paper to wipe the lens surface gently. Repeat the treatment with a fresh piece of lens paper as needed to remove the fingerprint. Never

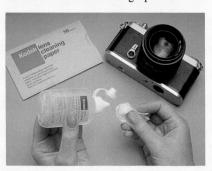

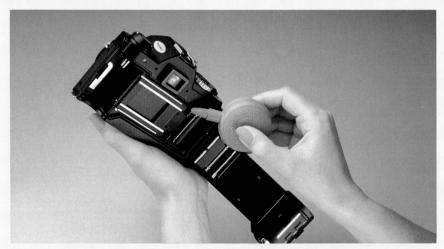

apply lens cleaning fluid directly to the lens. Fluid might seep into the lens around the edges and cause internal problems. Never use chemically treated eyeglass tissues to clean a camera lens. Camera lenses have special coatings that can be destroyed by chemically treated tissues.

When traveling, carry a small bottle of lens cleaner, a packet of lens cleaning paper, and a camel's-hair brush.

Clean the Battery Contacts

Modern automatic cameras depend on battery power. If the battery contacts aren't clean, malfunctions may occur. Before you install new batteries in a camera or other photographic equipment, rub the battery contact surfaces vigorously against a roughfinish cloth or scrub them with a clean pencil eraser. Then scrub the contacts in the battery compartment with a pencil eraser to remove minor corrosion that may impede current flow.

When installing the batteries, avoid touching the contacts with your fingers. Skin oils leave a coating that can impede current flow.

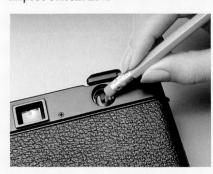

Clean the Film Chambers and Camera Back

Each time you unload the camera, glance at the film chambers, the area around the film guide rails and the pressure plate and camera back. Dust and film chips can accumulate in these areas and scratch film or work their way into the camera mechanism. Gently blow or brush particles away. Don't touch the shutter mechanism.

Check Batteries

Check your camera's battery power frequently. This step is as important, perhaps more important, than any of the others. Most cameras have a battery check switch. Since metering and automatic exposure systems shut down without power, dead batteries could leave you with severely restricted or no camera functions—unless you have a spare set of batteries, which you should carry. Seemingly dead batteries may spring to life if you rub the battery and camera contacts with a cloth or a pencil eraser.

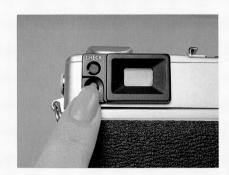

Clean the Exterior

When you have finished a day's shooting, examine the exterior of the camera for dust, sand, or moisture. If you spot any, blow it away with a squeeze-type air bulb. Always blow dirt away from crevices or openings in the camera body. The object is to move dirt off the camera, not into it. Follow with a gentle wipe-down using a clean, dry, soft lintless cloth. When storing the camera, keep it in a case, equipment bag or even a clean paper bag to protect it from dust.

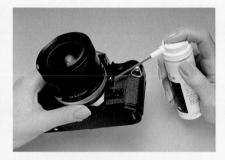

Clean the Viewing System

The better you can see through the camera, the easier it is to make pictures. With an optical viewfinder, check the eyepiece and front window or windows. They often become dirty and impair your view. Clean these surfaces as you would a lens. If the eyepiece lens has become oily from eyelash contact, apply lens cleaner on a cotton-tipped swab.

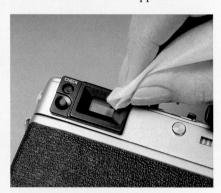

With SLR cameras, clean the eyepiece lens occasionally as just described. If you notice dirt specks on the ground glass, do not attempt to remove them unless the focusing screen is an interchangeable one that you can remove and reinstall easily. Remove the screen as outlined in the owner's

manual, and try to blow the dirt specks away. If that fails, reinstall the screen, and have it cleaned professionally.

If you notice while changing lenses that the reflex mirror inside the camera body has become dusty, take it to a repair facility for professional cleaning. The mirror coating is delicate and should only be cleaned by skilled personnel.

Beware of Heat and Cold

The safest assumption you can make for the health of your camera and the film inside it is that they will be comfortable where you are comfortable, and they will be uncomfortable where you are uncomfortable.

In hot areas, never leave a camera in direct sunlight for long. At the beach, cover your camera with a white towel or shade it under an umbrella. Never leave photo equipment or film in the glove compartment or trunk of a car in hot weather. Temperatures in these areas can reach oven-like levels. If your photo gear will be exposed to heat for long periods, keep it and your film in an insulating chest.

In a cold environment, keep your camera under your coat to keep it from becoming cold—the cold can sap your batteries of power. Remove it only long enough to make a picture. Advance film slowly and smoothly in cold weather to avoid static marks, which may occur if the air is very dry. In extreme cold, film becomes comparatively brittle and can tear or break if wound or rewound too rapidly. Do not bring a cold camera indoors without protection. A cold camera in the warm indoors can result in condensation on the exterior and even inside the lens. Moisture and electronics do not mix. Before bringing a cold camera indoors, place it in a plastic bag and squeeze out the air. After a half hour or so indoors, you can remove the camera from the bag. Should any condensation appear, wipe it off immediately.

Electronic flash

A century ago a photographer made a flash of light by igniting a combustible mixture containing magnesium powder. The results were clouds of smoke and frightened subjects. Today a photographer uses a portable flash unit that gives thousands of flashes and is powered by a few small batteries. The results are pictures made possible any time and any place. Portable electronic flash units range in size from pocket models to handle-mount units that are about the size of a telephone receiver. Electronic flash units yield light similar to daylight. They produce light by storing battery-supplied electrical energy in capacitors and releasing it in a miniature lightning bolt generated in a flash tube. The resulting burst of light is intense and brief.

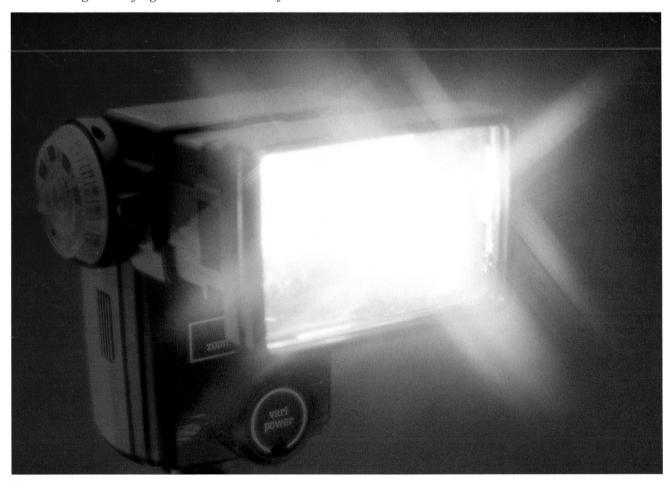

TYPES OF FLASH UNITS

There are three types of flash units. They vary on how they regulate light output and how they relate to the camera. The most basic type of flash is manual flash. The intermediate type is automatic flash, and the most advanced is an offshoot of automatic flash called dedicated flash. Each can be used successfully with relative ease.

Manual Flash Units

Manual, or nonautomatic, flash units emit flashes of the same intensity and duration each time they are fired. You or your automatic camera must adjust the lens aperture for proper exposure. Most flash units have a calculator scale to aid determining exposure. You set the film speed on a dial on the flash unit. The calculator scale then indicates an aperture appropriate for the flash-to-subject distance.

Automatic Flash Units

Automatic flash units regulate their own flash output, usually by varying the flash duration, to provide proper exposure. Such units normally must be set to the film sensitivity and sometimes to one of several possible power settings. Then you set the camera lens to a specified *f*-stop. The unit will adjust its light output to provide correct exposure throughout a specified distance range.

Dedicated Flash Units

Certain automatic flash units are designed for use with specific camera models. Such units are referred to as dedicated. Like automatic units, they regulate light output by varying flash duration. Their distinguishing feature is that they contain special circuits that permit the exchange of exposure-control data between camera and flash unit. With these units, the camera's metering system may control the flash unit. Often, the circuitry also permits the camera to fire or not fire the flash according to the amount of light perceived by the

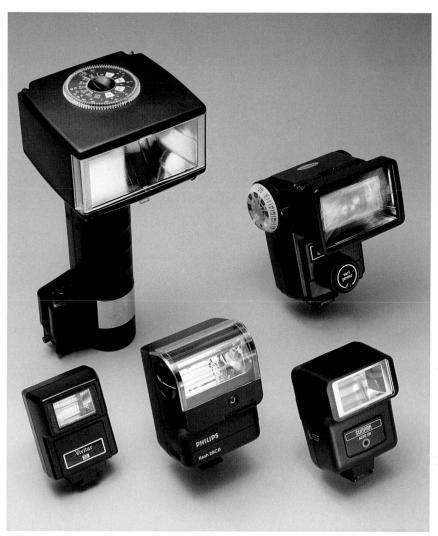

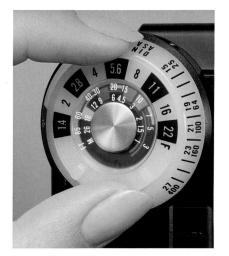

The first step in using an automatic flash unit is to set it for the ISO (ASA) speed of the film you are using.

Flash units come in many sizes and shapes. Generally, the bigger the flash unit, the more powerful it is.

camera's exposure meter. Other functions may also be provided. For instance, attachment of a dedicated flash to the camera often automatically sets the shutter speed. If you have a dedicated flash unit, review the flash manual alongside that for the camera until you are sure what to expect in various situations.

SHUTTER SPEEDS WITH ELECTRONIC FLASH

The shutter speeds you can use with electronic flash depend largely on the type of shutter in your camera.

SPEEDS WITH LEAF SHUTTERS

Most cameras with noninterchangeable lenses use some variation of a betweenthe-lens leaf shutter. This type of shutter is positioned in the lens barrel between lens elements. It is composed of several metal blades or leaves that swing outward to open. The moment the opening forms, the entire frame of film is exposed to incoming light. All leaf shutter speeds are normally usable with electronic flash, as all expose the entire frame of film simultaneously. (Some cameras with leaf shutters may not synchronize electronic flash at all speeds; check the owner's manual to be sure.)

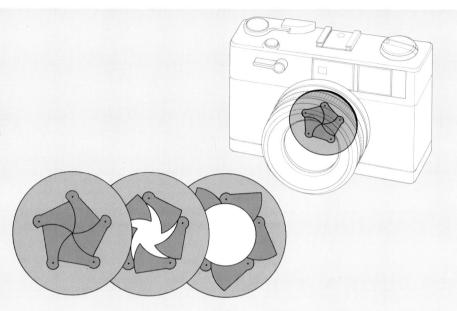

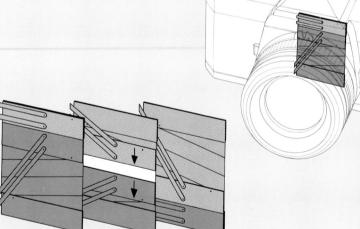

SPEEDS WITH FOCAL-PLANE SHUTTERS

Many cameras with interchangeable lenses and virtually all current 35 mm SLR models use focal-plane shutters. Located just in front of the film, focalplane shutters move either horizontally or vertically. These shutters consist of two rolled-up curtains like miniature window shades or sometimes two sets of horizontally overlapping metal blades (shown above). The practical operating sequence is similar in either case. At slow shutter speeds, the first curtain or set of blades snaps open and uncovers the whole piece of film to light. When the proper time has elapsed, the second

curtain or set of blades closes and covers the film again. Any speed in this slow range is normally suitable for use with electronic flash from the standpoint of synchronization. The highest speed at which the entire film frame is exposed to light simultaneously is often color-coded, marked with an X or identified with a lightning symbol. That distinctively marked shutter speed is the highest at which proper synch will be obtained with electronic flash. The speed varies with shutter design, and may be anywhere from 1/30 second to 1/125 second. The owner's manual lists

the highest synchronization speed for your camera.

At higher shutter speeds, focal-plane shutters do not expose the entire film frame instantly. At higher speeds, the second curtain or set of blades begins to follow the first shortly after it has begun to move. Together they form a narrow slit. The slit sweeps across the film, "painting" a band of image-forming light as it moves. The faster the shutter speed, the narrower the slit. The moving slit would pose no problem if the flash produced light the whole time the slit was moving across the film. However, the burst of light typically lasts from 1/50,000 to 1/1000 second. Thus the light from the flash disappears almost before the slit begins to move. Only the film directly behind the slit receives light at any one instant. If you set the camera at too fast a shutter speed for flash synch, your pictures will be only partly exposed.

It is normally desirable to select the highest shutter speed at which proper synchronization occurs. You want to make sure that existing light doesn't create noticeable ghost images in the picture, along with the sharp flash exposure. The slower the shutter speed you use with flash, the more likely you are to pick up traces of existing light. Interesting pictures can be made by combining flash exposure with existing light. If you try, use a tripod to keep the existing-light exposure sharp.

FLASH SYNCHRONIZATION

To make a picture with flash requires perfect timing between camera and flash. The flash must fire only when the film has been fully uncovered by the shutter. This perfect timing is called synchronization. Synchronization is achieved by an electrical connection between the flash and shutter. Just as the shutter fully opens, it trips a switch that fires the flash. With 35 mm SLR cameras, the shutter must be set at a critical speed (or slower), typically 1/60 second, to uncover the film fully for successful synchronization. With many non-SLR cameras the shutter speed isn't critical. Check your camera manual to be sure.

If set at too fast a shutter speed for flash synch, a focal-plane shutter cuts off part of the picture.

Synchronization selectors

Some cameras have synchronization selectors that adjust a single synch outlet for use with either electronic flash or expendable flash bulbs. Double-check that the selector is set properly. Electronic flash synch is commonly indicated by an X or a small lightning symbol. Consult the owner's manual for specific data. Some cameras permit synch selection via two separate receptacles. Make sure you plug the tip of the electronic flash synch cord into the appropriately marked outlet.

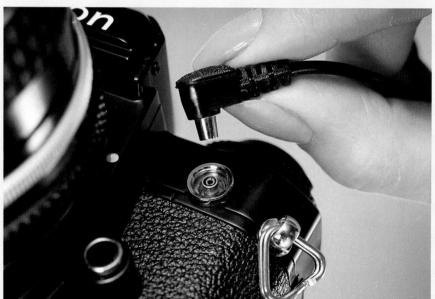

Cord synchronization

Many 35 mm cameras are equipped with standard synch receptacles that accept plug-in synchronization cords. Such receptacles may be provided in addition to or in place of a hot shoe. The flash can still be mounted atop the camera. However, with a long synch cord the flash can be held or mounted away from the camera. Many flash units may be synchronized via hot shoe or cord. Hot-shoe synchronization is easier. Cord synch is more flexible in terms of positioning the flash unit.

Many cameras have flash synch outlets that accept the plug of a standard synch cord.

A hot shoe is a flash-mounting shoe with built-in contacts that permit synchronizing flash without a connecting cord. Only flash units with appropriately wired mounting feet can be used in this manner.

Hot-shoe synchronization

The simplest synchronization link between flash and camera is the hot shoe. A hot shoe is a camera flash mounting shoe on top of the camera. It has built-in synchronization contacts. When the mount foot of a flash unit designed for wireless synch is inserted into the shoe, a matching set of built-in synchronization contacts mates with the contacts in the shoe. No external wiring is required.

EXPOSURE WITH AUTOMATIC FLASH

Automatic flash units adjust their own light output. Most of them incorporate a high-speed, light-sensing system that measures the flash illumination reflected from the center of the scene that is being lighted. When the unit senses that enough light has been reflected from the subject to expose the film properly, it turns off the light. For details of how your flash unit works, study the owner's manual. There is considerable variation among different models.

Generally, automatic flash units produce proper exposure under most normal shooting conditions. However, they can be fooled. If the unit senses an extremely bright reflection from an unusually light-toned area, it cuts off the exposure early, possibly underexposing more average-toned adjacent areas. Conversely, if the unit

senses a weak reflection from an unusually dark-toned area, it prolongs the light output, possibly overexposing average-toned areas.

You can avoid these exposure failures. Know the approximate area the flash sensor reads at various distances. Switch to the manual flash exposure mode when you think the unit will probably be misled by atypical subjects. Virtually all automatic flash units can be used manually when necessary. Calculate exposure with the calculator dial or with the guide number, as outlined under "Exposure With Manual Flash Units" on the next page.

If the sensor of an automatic flash unit reads the light reflected from an unusually light area in the scene, average-toned subjects will be somewhat underexposed. If it reads light from an unusually dark area, average-toned subjects will be somewhat overexposed.

Derek Doeffing

EXPOSURE WITH MANUAL FLASH UNITS

With nonautomatic flash units, the exposure setting must be changed for each significant change in flash-to-subject distance. All exposure adjustments are made with the lens aperture. Changing the shutter speed does not affect flash exposure except as it permits or does not permit proper synchronization.

Many flash units have a built-in calculator or table that relates film sensitivity to specific *f*-stops to use at various shooting distances. Refer to the owner's manual for specific instructions.

Manual flash units often have a table or a calculator dial for determining exposure quickly. Set the speed of the film, then find the lens aperture opposite the flash-to-subject distance.

GUIDE NUMBER CALCULATION

If your unit lacks a built-in calculator, you can calculate flash exposure easily by the guide number method. The instructions accompanying a manual flash unit will list guide numbers to be used in conjunction with films of different sensitivities. The guide number changes with film speed. Be sure to choose only the guide number for the speed of the film you are using. Then divide the guide number by the distance from the flash to the principal subject it will illuminate. The resulting number is the aperture to set on the camera lens. For example, if the guide number is 40 and the flash is 10 feet from the subject, set the lens to f/4 (40 divided by 10 equals 4). Note that two separate guide numbers may be given for each film speed, one for use with distances expressed in feet, the other for distances expressed in metres. Make certain you pick the right guide number for the distance units you use. If you err here, you will obtain grossly incorrect results.

Remember to recalculate exposure when you change shooting distance. If you want to minimize calculations for

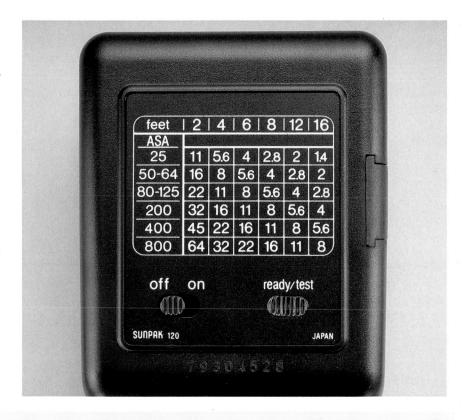

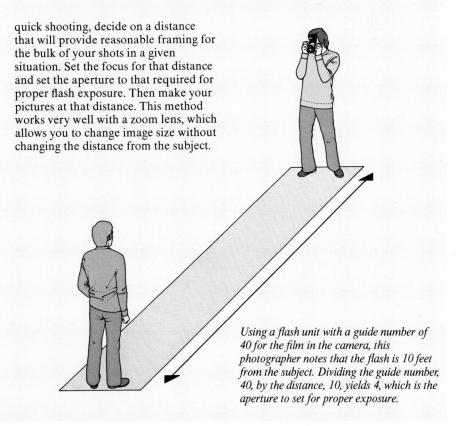

FILL-IN FLASH

You can use electronic flash to lighten intense shadows in brightly lighted outdoor settings. Known as fill-in flash, this technique is especially effective in portraits where dark shadows can mar a face. The technique requires you to establish an overall exposure that works for the daylighted portion of the subject while allowing the film to record enough flash exposure to open up the shadow areas. The procedure is most easily controlled with the camera and flash unit set for manual operation.

FILL-IN FLASH CALCULATION

Begin by using the camera meter to find the correct exposure for the scene. Do not use a shutter speed faster than the highest flash-synch shutter speed. When using high-speed film on bright days, you might find that even the smallest aperture will not prevent overexposure. For fill-in flash on sunny days, use a slow- or medium-speed film. KODACHROME 25, KODACHROME 64, and KODACOLOR II Films are good choices.

Now decide how much you want to lighten the shadows. Results generally look best when shadows are 1 to 2 stops darker than highlights. That means you should use your electronic flash at a distance corresponding to one to two apertures wider than that actually set on the lens. If the lens is set at f/11, place the flash at the distance proper for f/8 or f/5.6. If the lens is at f/16, place the flash at the distance proper for f/11 or f/8.

Here's an example of using fill-in flash. Assume that the camera meter indicates an exposure of 1/60 second at f/16 for the brightly lighted part of the scene, and that 1/60 second is the fastest synch speed available. For the shadows to record about a stop darker, they would have to be lighted by the flash to the equivalent of f/11, a 1-stop wider aperture than that set on the lens. To find how far to place the flash from the subject, look at f/11 on the flash calculator scale. The distance corresponding to f/11 is how far the flash should be from the subject. In this instance, 4 feet (1.2 m) corresponds to f/11 on the flash calculator scale. Stand or place the flash 4 feet (1.2 m) from the subject for fill-in flash.

For maximum flexibility in adjusting flash versus background exposures outdoors, use a zoom lens and an extension synch cord. The zoom lens will let you change your image size easily. A long extension synch cord plus a light stand or cooperative person to hold the flash will let you vary the flash-to-subject distance.

Without flash fill, the shadows in the top picture obscure the girl's face. With flash fill, the shadows are lightened, clearly showing the girl's face yet retaining the feeling of the natural light.

OFF-THE-CAMERA FLASH

Often you can get better lighting effects when you don't mount the flash on top of the camera. When mounted atop the camera, a flash gives flat, nearly shadowless frontlighting. Held high or off to the side, it gives lighting that adds modeling and a sense of texture. The end result is that the subject takes on more form and depth. If you expect to do much off-camera flash, buy a lightweight light stand and a long synch cord. You may also need a mounting adapter to fasten the flash unit to the light stand. Automatic flash units can be used automatically in many remotely mounted applications. Some dedicated units, when removed from the camera's special hot shoe, lose their automatic light regulation and have to be used as manual flash units. See the owner's manual to determine the case with your unit.

Held off to the side with an extension synch cord, off-camera flash adds modeling that gives form to the subject, top. Mounted atop the camera, head-on flash gives flat, harsh lighting that minimizes the form of the subject and may bleach out subtle colors, bottom right.

BOUNCE FLASH

Bounce flash consists of aiming the flash at a ceiling, wall, or reflecting card so that the light reflects onto the subject. Bounce flash creates much softer, more even area lighting than direct flash. Shadows soften and highlights broaden. The reflective surface will flood the subject area with a broad, soft light. Although ceilings and white walls work well, don't use colored surfaces if you are using color film. They will reflect colored light that will tint your subject. They can be used, however, as bounce surfaces with black-andwhite film.

If you have an automatic flash unit, you can use it on automatic for bounce flash only if the unit has a movable head or light sensor. The sensor must be pointing at the subject while the head points at the bounce surface. If you cannot aim the head and sensor in different directions, the sensor will turn off the light when the bounce surface, instead of the subject, has been adequately illuminated. If your automatic flash doesn't have a movable head or sensor, use it on manual. If it doesn't have a manual setting, you can make it act like a manual flash by covering the sensor with your finger during exposure.

To use your flash unit on automatic, first determine the total distance from the flash to the bounce surface to the subject. On the flash calculator dial, find the maximum distance on the automatic-distance range for the aperture you are using. It should be at least 1.4 times the total distance you just determined. If it is, proceed to use your flash as usual. If it isn't, you have several choices: use a larger aperture, move closer, use a higher speed film, or use the flash on manual. Using the flash on manual may be your simplest alternative.

Some automatic units have a confidence light to help you determine if there is sufficient light for proper

Compare the bounce flash picture, **above**, to the head-on flash, **right**. You can see that bounce lighting gives a soft, uniform, diffuse light. It also gives a pleasing appearance over a greater depth than normal head-on flash.

exposure. A confidence light is typically a green indicator that lights up if enough light reaches the subject when you test fire the flash. With bounce flash, a confidence light will be accurate only if the flash is on automatic and the sensor is pointing at the subject.

BOUNCE FLASH WITH A MANUAL UNIT

To calculate exposure for bounce flash with a manual unit, estimate the total distance from the flash to the bounce surface and from the bounce surface to the subject. Now find the aperture that corresponds to this distance on the calculator dial. Set an aperture that is 1 or 2 stops larger than the indicated f-stop. A larger f-stop is required because the bounce surface does not reflect all the light striking it. Bounce flash is somewhat unpredictable, so bracket your exposure. You might want to make a test roll varying apertures for future reference.

You can produce soft, even lighting over a large area by bouncing the beam of an electronic flash unit from a reflecting surface such as a ceiling or wall. The pool of light on the reflecting surface serves as a large light source. When calculating exposure for bounce flash in the manual

mode, estimate the flash-to-bounce-surface distance and the bounce-surface-to-subject distance, and then add them. Set the lens aperture 1 or 2 stops larger than the aperture corresponding to this distance on the calculator dial (see text).

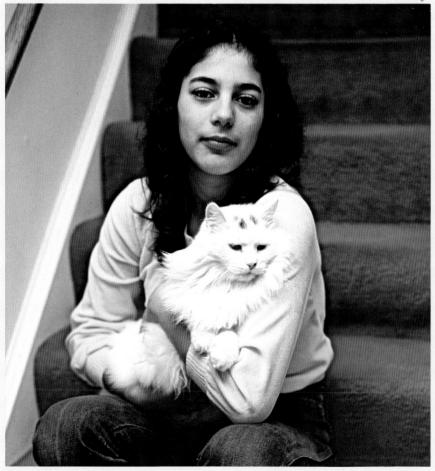

QUICK TIPS FOR FLASH PHOTOGRAPHY Check synchronization

Select an appropriate shutter speed. If using a synch cord, plug it into the correct contact.

Clean the battery contacts

Dry-scrub battery contacts with a clean pencil eraser to assure proper current flow

Use fresh batteries

Replace or recharge flash batteries when the unit begins to take too long to recover between shots. Put a piece of masking tape on the flash unit and note on it the date you replaced or recharged the batteries.

Don't kink flash cords

If you use synch cords, don't kink or bend them sharply, because the fine wires inside break fairly easily. If your flash fires intermittently, suspect the synch cord first. Keep a spare cord on hand.

Don't jump the ready light

When you're shooting action or working with an autowinder, keep an eye on the flash-ready indicator on the flash unit or in the camera. Don't shoot before it comes on, or you risk noticeable underexposure. When the recycling time between flashes grows too long, replace or recharge the flash batteries.

Do not aim the flash at mirrors or other highly reflective materials. The reflection of the flash will spoil the picture. By simply stepping to one side you can change the angle and eliminate the reflection.

Accessories

Accessories for cameras range from the exotic to the indispensable, from right-angle lenses to sturdy tripods, from bubble levels to motor drives. As you specialize in certain areas, you'll probably find that your camera, although it is a precise and finely tooled machine, has limitations. You can push back these limitations—with accessories. Whatever it is you want to do with your camera, dunk it in the water or see around a corner, there's probably an accessory that'll help you do it. In this chapter we discuss some of the more common and more useful accessories that can help you with your photography.

ADDING EQUIPMENT TO EXPAND YOUR HORIZONS

As your interest in photography grows, you will probably want to add to your equipment. Many photographers fall under the spell of the deep black finishes and smooth shiny surfaces of lenses, flashes and other gear. They become equipment buffs. You, too, may be tempted by the electronic flashes, zoom lenses, and filter systems beckoning with the promise of better pictures.

Should you give in? Only you can answer that. Remember that although a piece of equipment cannot substitute for creativity, it may help you solve specific technical problems. To a nature photographer, a macro lens is indispensable. To a portrait photographer, a moderate telephoto lens is invaluable. Before you buy new equipment, analyze your needs.

A key question to ask is: Is there a reasonable way to get the results I want with equipment I already own?

Another question to ask is: *How much will I use the new equipment?* A given type of lens or accessory may be available in models ranging from Spartan to deluxe. An economy model may be perfect for occasional use, but you might prefer to go first class with an item that will see frequent service.

Photography often poses problems to which there are multiple solutions. So it pays to familiarize yourself not only with accessories produced by the manufacturer of your camera, but also with those available under other brand names. Independent manufacturers sometimes make types of lenses or accessories that aren't represented under a camera-brand label. And sometimes several different types of equipment can do the same basic job but with different working procedures or degrees of convenience. Which is best for you may depend purely on personal taste or specific needs.

TRIPOD AND CABLE RELEASE

If you make long exposures or shoot with long lenses, get a sturdy tripod. Tripods come in a profusion of designs and sizes and weights. As a rule, you will do well to pick the heaviest, most rigid tripod you can live with. Although the heavier units give greater stability, be practical in your selection. Choose one that won't unduly burden you when you carry it. A movable center post on which the camera can be raised and lowered without changing leg length is a great convenience, as is a camera platform that can tilt up and down and side to side as well as pan horizontally.

A cable release is simply an extension that allows you to trip the shutter without pressing the button directly. It reduces the likelihood of moving the camera at the moment of exposure. Some recent cameras use electrical extension tripping cables rather than conventional cable releases. The best cable releases are long and flexible. They lie slack enough and limp enough not to transmit minor motions of your hand and fingers to the camera.

A tripod with a camera platform that tilts side to side as well as forward and back makes it easy to position the camera as you wish. Make sure you can orient the camera conveniently for composing vertical scenes.

LENS SHADES

A lens shade, or hood, attaches to the front of a lens. It prevents stray light from entering and creating light flares that degrade the image. Lens shades are made in different sizes and shapes to meet the requirements of lenses of different focal lengths. Shades for telephoto lenses are generally long and narrow while those for wide-angles are relatively short and widely flared. Only use a lens shade on a lens of the focal length for which it was designed. If you use a wide-angle lens shade with a telephoto, it won't provide optimum protection. If you use a telephoto lens shade on a wide-angle, it will cut off, or vignette, corners of the image. Lens shades also provide some physical protection for the front surface of the lens.

Lens shades come in different sizes and shapes to provide optimum efficiency with lenses of different focal lengths. Lens shades help prevent stray light from degrading image quality.

FILTERS

Polarizing Filter

A polarizing filter usually screws onto the front of the lens. It may be used to darken blue skies, remove reflections selectively, and to increase color saturation. Polarizers are usually mounted in a ring that allows the filter to rotate freely. With an SLR camera, you rotate the polarizer while observing its effect on the image. As you rotate it, reflections in the scene may become subdued or disappear. When you see an effect you like, take the picture. Even when there are no noticeable reflections. minute specular reflections in a scene may cause colors to record weakly on film. Removing such reflections increases color saturation, or intensity, in the picture. Again, the effect is visible through the finder. Similarly, a polarizer is useful for intensifying the blue of a clear blue sky in areas at 90 degrees to the sun. If you don't have an SLR, you can still use a polarizer, but you will have to judge the effect by looking through the filter before placing it over the lens. When you see the effect you want, place it over the lens without rotating the filter further.

A polarizer typically absorbs enough light to require an exposure increase of approximately 1½ to 2 stops, depending on circumstances and personal taste. Most built-in meters that can read through filters can read accurately through a polarizer. Consult your camera manual for information about using a polarizing filter with your camera. If your camera meter cannot accurately measure light passing through a polarizing filter, use your camera in the manual mode.

Make an ordinary exposure reading of the subject, then set the controls to provide 1½ to 2 stops more exposure. Place the polarizer on the lens, rotate it to produce the desired effect, ignore the meter and take the picture.

Without Polarizing Filter

With Polarizing Filter: A polarizing filter is most often used to darken blue skies in pictures. While looking through the viewfinder, rotate the filter until you see the effect you want.

Skylight Filters

The No. 1A, or skylight, filter is used with color slide films to reduce excess bluishness that may occur in scenes in the shade or on overcast days. It also removes some of the excess blue associated with photography at long distances and with aerial shots. No exposure adjustment is required. A skylight filter is not necessary with color negative films because the photofinisher can adjust the color balance during printing. A skylight filter can also protect a camera lens from fingerprints, sand, ocean spray, and scratches.

The strongly colored filters used to alter contrast with black-and-white films can also be used to produce unusual effects with color films. This striking picture was made through a No. 25 red filter.

atty Van-Dols

No Filter

No. 8 Yellow Filter

Filters for Black-and-White Pictures

Colored filters in various strengths of red, yellow, green, and blue are used to selectively alter the contrast of black-and-white films. You can use them to lighten or darken objects of certain colors relative to the tonal values with which other subjects are recorded. They are most often used to darken a blue sky so the clouds appear lighter. The basic rule is that a filter allows objects of the same or similar colors as the filter to record lighter than normal, but darkens the rendition of objects of a complementary color. The same filters can also be used with color films to create strongly colored special effects.

Most meters that read through filters will compensate adequately with the filters in this category, although exceptions can occur. You can check your meter by comparing the exposure settings before and after attaching a filter. The after settings should correspond to the exposure changes recommended in the filter table on this page. Consult the owner's manual for specific information about your equipment. And bracket exposures when seeking specific effects.

Increase

No. 25 Red Filter

FILTERS FOR DAYLIGHT PHOTOGRAPHY with general-purpose black-and-white films

Subject	Effect desired	Suggested filter	Color of filter	exposure time by	Or open lens
Clouds against blue sky	Natural	No. 8	Yellow	×2	1 stop
	Darkened	No. 15	Deep yellow	×2.5	11/3 stops
Blue sky as background for other subjects	Spectacular	No. 25	Red	×8	3 stops
	Almost black	No. 29	Deep red	×16	4 stops
Marine scenes when sky is blue	Natural	No. 8	Yellow	×2	1 stop
	Water dark	No. 15	Deep yellow	×2.5	11/3 stops
Sunsets	Natural	none or No. 8	None or yellow	×2	1 stop
	Increased brilliance	No. 15	Deep yellow	×2.5	11/3 stops
		No. 25	Red	×8	3 stops
Distant landscapes	Natural	No. 8	Yellow	×2	1 stop
	Haze reduction	No. 15	Deep yellow	×2.5	11/3 stops
	Greater haze reduction	No. 25	Red	×8	3 stops
		No. 29	Deep red	×16	4 stops
Nearby foliage	Natural	No. 8	Yellow	×2	1 stop
		No. 11	Yellowish-green	×4	2 stops
	Light	No. 58	Green	×6	2⅓ stops
Flowers	Natural	No. 8	Yellow	×2	1 stop
		No. 11	Yellowish-green	×4	2 stops
Red, bronze, orange, and similar colors	Lighter to show detail	No. 25	Red	×8	3 stops
Dark blue, purple, and similar colors	Lighter to show detail	none or No. 47	None or blue	×6	2⅓ stops
Architectural stone, wood, fabrics, sand, snow, etc, when sunlit under blue sky	Natural	No. 8	Yellow	×2	1 stop
	Enhanced tex- ture rendering	No. 15	Deep yellow	×2.5	1⅓ stops
		No. 25	Red	×8	3 stops

NOTE: If the exposure meter in your camera cannot accurately read light transmitted by a filter, first take an exposure reading without the filter attached. After attaching the filter, adjust the exposure according to this table.

SUPPLEMENTARY CLOSE-UP DEVICES

Although a macro lens is the best choice for anyone whose main interest is close-up photographs, there are good, economical alternatives. Close-up lenses and extension tubes offer an inexpensive means of taking close-up pictures. Simple close-up lenses that fit over your camera lens like a filter are the photographic equivalent of reading glasses. Known as supplementary lenses, they allow the camera lens to focus closer than it can unaided. These lenses are available in different strengths, expressed in diopters, for different field sizes

and shooting distances. They require no increase in exposure, but the camera lens should be closed down to a moderate to small aperture for sharpest results.

Supplementary close-up lenses can be used with almost any camera lens on which they can be mounted, but are most convenient to use on an SLR camera. With other types of cameras, auxiliary framing devices are usually needed.

Extension tubes are often supplied in sets consisting of three metal or plastic tubes of different lengths. An extension tube fits between an interchangeable lens and the camera body. Each longer tube lets you focus a little closer to the subject and make a larger image. All three tubes together provide the biggest image. With a normal lens, the biggest image with a full set of tubes attached is usually life size. Additional exposure is required when using extension tubes. Through-the-lens meters automatically compensate the exposure. If you buy extension tubes, check to see that they allow you to use your camera in the automatic mode. Some do not.

AUTOWINDERS AND MOTOR DRIVES

If you are an enthusiast of rapidaction shooting, you may want to try an autowinder or motor drive, providing your camera will accept one. Both are battery-powered, automatic film-advance mechanisms. Autowinders are smaller and lighter, and generally fire one frame per press on the release button. They may also have a continuous-run mode, in

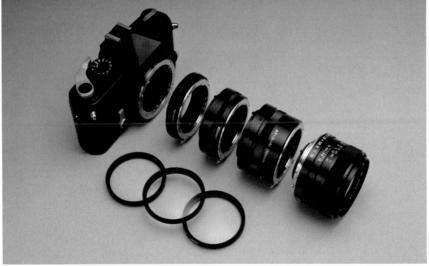

Shown above are extension tubes in line with the lens and supplementary close-up lenses, which resemble filters.

which the camera exposes and advances film at a rate of up to about two frames per second (fps) as long as the release button is held down. Motor drives are larger and heavier, and offer, in addition to single-frame operation, continuous-run speeds to five fps or faster.

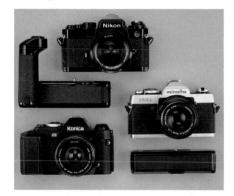

Autowinders and motor drives use battery power to advance film. They recock the shutter automatically each time you take a picture. Autowinders are lighter and more compact than motor drives, but usually cannot operate as fast in sequence photography. Some cameras have built-in autowinders.

CAMERA CASES AND EQUIPMENT BAGS

A camera case or equipment bag can provide welcome protection for your camera. If you travel light, with just a camera and few or no accessories, a conventional camera case provides cushioning against minor knocks and scrapes. Remove a detachable cover or take out the camera altogether while photographing to make sure the flap doesn't flop in the way of the lens.

If you travel with several rolls of film, a flash, and extra lenses, get a good equipment bag. A good bag should be sturdy enough to cushion the contents reasonably against minor shock and vibration and be large enough to accommodate everything with room to spare. It should be comfortable to carry and allow access to the contents without having to put it down. Look closely at seams and the attachment points for carrying straps and handles. The heavier your equipment, the stronger they should be.

Choose a camera bag large enough to hold your commonly used equipment. Some camera bags have moveable interior panels so you can design the interior to conform to the shape of your equipment.

About film

In the 1820's, Joseph Nicéphore Niépce took the world's first photograph on a pewter plate covered with a solution of bitumen of Judea, a form of asphalt. The exposure lasted eight hours. In the 1830's, Louis Daguerre developed the daguerreotype—a polished metal plate with a silver-mercury image. A typical exposure lasted twenty minutes. From those beginnings has evolved modern film that can make a picture with an exposure of 1/1000 second. With instant print film, you can even take a picture and watch it develop during a commercial break in your favorite TV show. The variety of films is great. From high-speed and slow-speed, from color and black-and-white, from negative and slide films, you must make a choice. Knowing some characteristics of film will help you choose.

FILM SPEED

The speed of a film indicates its sensitivity to light. Speeds are expressed in terms of ISO(ASA) numbers. These numbers appear on the film box and on the magazine, cartridge, or backing paper. The higher the ISO(ASA) number, the more sensitive the film is to light. The ISO(ASA) numbers are usually classified into three categories: slow speed (ISO [ASA] 25 to 32), medium speed (ISO[ASA] 64 to 125) and high speed (ISO[ASA] 160 to 400). There is a predictable relationship between ISO(ASA) numbers: A doubled number indicates doubled film sensitivity. A film rated at ISO(ASA) 100 is twice as sensitive as one rated at ISO(ASA) 50, and requires one half the exposure in any given situation.

To relate film speed to the real

world, follow this rule of thumb. On a bright sunny day, you can set your lens to f/16 and obtain proper exposure for a fully lighted outdoor scene by setting a shutter speed equivalent to 1 over the ISO(ASA) film speed. For example, with an ISO(ASA) 64 film and the lens at f/16, you would set the shutter to 1/60 second.

When you set your camera's meter system to the speed of the film, you are telling the meter how sensitive the film is. It will base exposure on that information. Be sure to set the meter to the proper ISO(ASA) number.

If all your shooting will be in fairly bright light, you can easily use medium-speed films, such as KODACHROME 64 and KODACOLOR II, or even a slow-speed film, such as KODACHROME 25 if you aren't photographing rapid action. If you antici-

Printed on the outside of a Kodak film box are the type of film, the film speed, the number of exposures, and the expiration date. Printed on the inside of the box is exposure information.

pate working in dim conditions or need maximum action-stopping capabilities, opt for a high-speed film, such as KODACOLOR 400.

SHARPNESS

Sharpness refers to a film's ability to record objects with great detail. Sharpness is best detected along the edges of recorded objects. Slow-speed films are generally sharper than high-speed films. The sharpness advantage of a slower film, however, may be negated under certain conditions by image motion incurred by using too slow a shutter speed or insufficient depth of field resulting from too wide a lens opening. And the theoretical sharpness disadvantage of using a high-speed film may be outweighed by the benefits of shooting at fast shutter speeds that stop motion and at small apertures that yield greater depth of field.

High sharpness is a characteristic associated with slow- and medium-speed films, such as KODACHROME 25, KODACHROME 64 and KODACOLOR II.

GRAININESS

At high enlarging magnifications, exposed and processed film reveals a granular texture known as graininess. With modern Kodak general-purpose films, graininess may not be apparent at normal enlargement and projection sizes. However, graininess becomes detectable at extreme magnifications. Slow-speed films can be enlarged to a greater degree than high-speed films before graininess becomes apparent.

If you make enlargements greater than 11 x 14 inches (28 x 35.6 cm), consider sharpness and graininess when choosing a film. But always pick a film with an eye to stopping action and achieving necessary depth of field.

Graininess is the granular texture of a film that becomes visible at high magnifications. This example was enlarged approximately 50X. Generally, slower films display less graininess at a given magnification than faster films.

BLACK-AND-WHITE FILMS

General-purpose black-and-white films are negative films that produce a tonally reversed negative from which a tonally correct print is made. Various colors and tones in the subject are rendered in the print as shades of gray.

General-purpose, black-and-white films cover a wide range of speeds, from a slow, fine-grained material, such as Kodak Panatomic-X Film, ISO(ASA) 32, to low-light specialties such as Kodak Recording Film 2475, ISO(ASA) 1000. Both Plus-X Pan, ISO(ASA) 125, and Tri-X Pan, ISO(ASA) 400 Films are good allaround films for everyday use. With its high speed, Tri-X Pan Film is especially suited for action and existing-light photography.

Black-and-white films generally produce good results without filtration, whether exposed by daylight, electronic flash, or commonly used artificial sources.

Kodachrome SLibe PROCESSED BY KODAK

Color transparency films are used to make color slides. The same piece of film you expose in the camera becomes the tonally correct color positive you view or project.

(Type A), ISO(ASA) 40, and KODAK EKTACHROME 160 (Tungsten), ISO(ASA) 160, are balanced for proper color rendition when exposed to various types of tungsten lighting. They may also be used with daylight or electronic flash when suitably filtered.

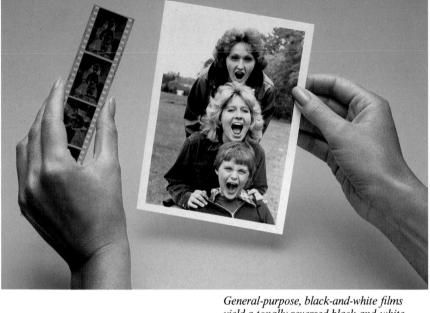

general-purpose, black-and-white films yield a tonally reversed black-and-white negative that is used to make a tonally correct black-and-white print. Subject colors are rendered as appropriate shades of gray.

Color slide films are also called color positive, transparency, or reversal films. The slide is the same piece of film exposed in the camera. After exposure and processing, it appears similar to the subject in tone and color and can be viewed directly, projected, or reproduced photomechanically for publication. Same-size or enlarged transparencies can be made from a color slide, as well as color prints.

Daylight-balanced color slide films, such as Kodachrome 25, ISO(ASA) 25, and Ektachrome 400, ISO(ASA) 400, are meant to be exposed by daylight or electronic flash. When exposed through appropriate conversion filters, they may be used with other light sources.

Tungsten-balanced color slide films, such as KODACHROME 40 5070

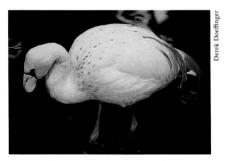

With KODAK EKTACHROME 400 Film, you can easily take pictures in the dark jungle of an aviary or at outdoor night events without using a tripod or flash.

COLOR NEGATIVE FILMS

Color negative films, such as Kodacolor II, ISO(ASA) 100, and Kodacolor 400, ISO(ASA) 400, are intended primarily for making color prints. The negative represents the subject in reversed tones and colors. Only the final print shows the subject realistically.

Color negatives can also be used to produce color slides for projection or black-and-white prints. Most color negative films are balanced for exposure by daylight or electronic flash but may be used with appropriate conversion filters with other light sources. A few special-purpose color negative films are balanced for use with professional studio lamps.

A color negative records the subject in reversed tones and colors. It is used to make a tonally correct print with realistic color rendition. If you are primarily interested in making color prints, use color negative films.

INSTANT PICTURE FILMS

Popular instant picture color films, such as Kodak Instant Color Film PR144-10, produce a full-color print just minutes after ejection or removal from the camera, with no additional processing required. Other types of instant-picture film are available for various camera models to produce black-and-white prints (with or without a reusable negative) or even black-and-white transparencies.

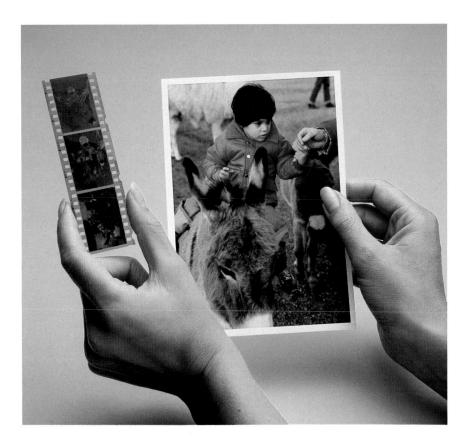

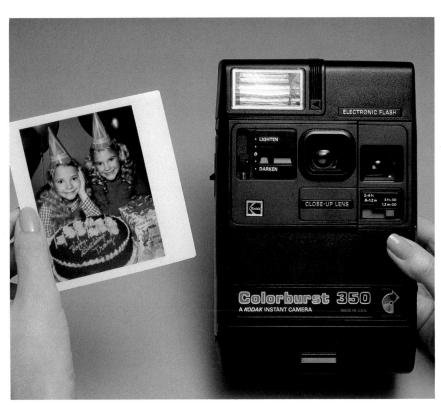

PROCESSING SERVICES FROM KODAK

Eastman Kodak Company provides a wide variety of processing services for users of Kodak color films. These services are available through photo dealers who can send in your film directly or provide you with convenient prepaid processing mailers. The services include processing Kodak color negative and slide films, making color prints and enlargements from negatives and slides, making duplicate slides from color slides and making slides from color negatives.

Kodak laboratories also make internegatives from color slides. Internegatives are special color negatives that may in turn be used to make color or black-and-white prints.

A special processing service available from Kodak laboratories through dealers and via Kodak Special Processing Envelopes, ESP-1, effectively doubles the film speed of several Kodak Ektachrome films. This service applies only to 35 mm and 120 roll films.

With KODAK Mailers you can send your Kodak color film for Kodak processing.

Kodak does not provide blackand-white developing and printing services. Black-and-white processing is available through independent laboratories, as are many color services.

For best results, have film processed as soon as possible after exposure.

EXPOSURE LATITUDE

A film's latitude is its ability to produce a usable picture even if somewhat overexposed or underexposed. Different types of films vary considerably in their latitude. If you expect to make pictures under difficult lighting conditions, a film that exhibits wide exposure latitude is desirable. Negative films generally have more exposure latitude than slide films. KODACOLOR 400 Film, for example, can produce good results with 1 stop underexposure and 2 or 3 stops overexposure. In large part, negative films have more latitude because print exposure can be adjusted during printing. But don't make a habit of counting on exposure latitude to make up for incorrect exposure.

Kodak color negative films produce acceptable results even when underexposed by 1 stop or overexposed by 2 stops.

Negative, -1 stop

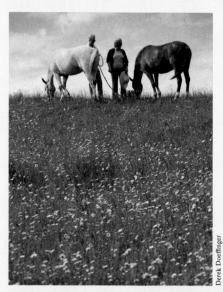

Negative, +2 stops

SPECIAL PROCESSING

The speed of KODAK EKTACHROME, PLUS-X Pan, and TRI-X Pan Films can be doubled with extended development during processing. For instance, EKTACHROME 400 Film has a speed of ISO(ASA) 400. However, it can be rated at ISO(ASA) 800 when appropriately processed. Why increase the speed of a film? Because sometimes you need a faster shutter speed or a smaller aperture, especially in existing-light or sports photography. EKTACHROME 64, EKTACHROME 160, and EKTACHROME 200 Films can also be doubled in speed. The whole roll must be shot at the same film speed. Notify your photofinisher that you doubled the film speed. If you are using Kodak processing, buy a KODAK Special Processing Envelope, ESP-1, for each roll of film. Increasing the film speed will result in contrastier colors and slightly grainier images. Do not try to increase the speed of KODACHROME and KODACOLOR Films. It isn't practical.

Many photographers who do their own black-and-white processing favor Kodak Tri-X Pan Film for doubling the speed. Some photographers drastically increase the film speed because they like the grainy result. Graininess progressively increases with any increase in film

For low-light photography, you can effectively double the film speed of several Kodak Ektachrome color films.

speed. The extended development times required to boost Kodak black-and-white film speeds are listed in the *KODAK Black-and-White Darkroom DATAGUIDE*, Publication R-20.

Film latitude is a film's ability to produce a usable result despite a given amount of overor underexposure. For slide film the correct

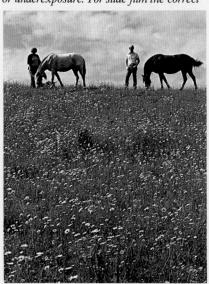

Slide, -1 stop

exposure, far right, looks best, but pictures over- and underexposed 1 stop are also acceptable. Two stops of over- and

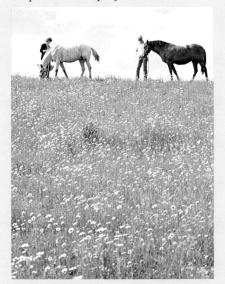

Slide, +1 stop

underexposure, however, usually exceed slide film's latitude.

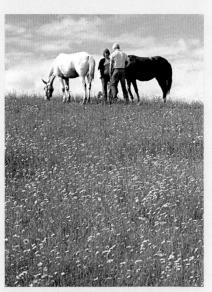

Slide, correct exposure

Elements of the picture

Understanding your equipment and film only starts you on the road to taking good pictures. To complete your journey you need an awareness and understanding of the photographic elements of a scene that can make a good picture. Chief among the photographic elements is the very one which makes possible both photography and sight: light.

UNDERSTANDING THE ELEMENTS

The elements of the picture are not abstractions but are real things in the world as readily perceived as a rising full moon. When the presence of one of these elements stirs you like a moonrise you'll know that you have been properly sensitized. Until then, discipline yourself to analyze consciously how the elements in the scene before you can be best used.

What are these elements? The most obvious but least considered is light. Although there are as many varieties of light as there are paint chips in a paint store, we take light so for granted that we are often at a loss to describe it beyond saying it's bright or dim. In photography, light cannot be taken for granted. Other important elements are color and texture.

DIRECTION OF LIGHT

Light can come from the front, from the back, from the side, from above, even from below and countless positions intermediate to all of these. Frontlighting, sidelighting, backlighting, and toplighting are the four most important directions of lighting. Each change in lighting position changes the appearance of the subject and its apparent relationship to other parts of the scene.

The shadows resulting from light are as important as the highlights. The highlights reveal detail. The shadows veil detail. Together, highlights and shadows define form and texture.

A subject that appears lacklustre and lifeless from one lighting direction may appear sparkling and spirited under light from a different direction.

Frontlighting

Light that illuminates the subject from the position of the camera is called frontlighting. The sun shining from behind you during picture-taking gives frontlighting. Frontlighting illuminates the side of the subject facing the lens and casts shadows behind the subject, where they are largely unseen by the camera. Without shadows subjects look less three-dimensional than they are. The even, shadowless light of frontlighting results in flat-looking subjects.

Automatic exposure systems handle frontlighting quite well. Care is required, however, for highly reflective or nonreflective subjects, as well as normal subjects against lighter or darker backgrounds.

Frontlighted, a subject looks somewhat flat because few shadows are visible to the camera. Subtle colors may be bleached out.

Sidelighting

Light that comes from either side of the subject and skims the surface is called sidelighting. Both the highlights and their corresponding shadows are visible from the camera position.

Sidelighting emphasizes form and texture. With it, the furrows of a plowed field stand out like miniature mountain ranges. A variation of sidelighting, with the light source high and located halfway between direct sidelighting and direct frontlighting, is often used for photographing people. It models the facial features better than frontlighting, yet doesn't throw half the face in shadow, as does pure sidelighting.

When faced with sidelighting, automatic exposure systems usually but not always produce correctly exposed pictures. Sidelighted subjects seldom pose a problem if they show an even mixture of shadows and highlights. However, be alert when a massive highlight area adjoins a massive pool of shadow. In such cases, determine whether you want to increase detail in the shadow or maintain detail in the highlight. For more shadow detail open up ½ or 1 stop from the meter reading. To preserve highlight detail, close down ½ or 1 stop from the meter reading. Bracket when in doubt.

Sidelight skims across a subject emphasizing its surface characteristics. If a large shadow is present in the scene, adjust exposure to obtain normal rendition of the bright areas.

Backlighting

Backlighting occurs when the light source is behind the subject. Shadows stretch forward toward the camera, creating the illusion of great depth. A rim of light outlines subjects in the scene and separates them from each other and the shadows. The separation enhances the feeling that multiple planes exist within the photograph. The air and translucent subjects such as flowers and blades of grass seem to glow. With backlighting you can create bold, dramatic pictures. Underexpose to make silhouettes. Play the unusually long shadows against the glowing highlights to make bold patterns.

Automatic exposure systems often need help with backlighting. While metering be sure that the sun or any other light source is not shining directly into the lens. Otherwise underexposure results. Either frame the picture with the light source outside the view of the lens or hide the light source behind a tree or building. The meter should now give good exposure. These steps also reduce the

likelihood of flare showing up in your pictures as bright streaks or hot spots.

When photographing backlighted scenes with slide film it is always good to bracket 1 or 2 stops either way from what the meter suggests. With negative film simply increase exposure by 1 or 2 stops. When taking backlighted portraits you'll want to show detail in the face. The easiest way to increase facial detail is to increase exposure by 1½ stops. However, this method will overexpose the highlights. To provide facial detail yet preserve the highlights, add light to the face with reflectors or fill-in flash.

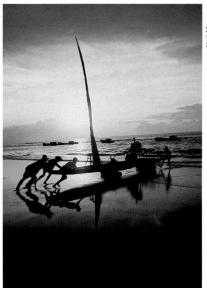

To produce a silhouette, set the exposure for the bright background behind the subject.

Backlighting creates the illusion of multiple planes in a photograph. Shadows cast toward the camera enhance the illusion of depth.

Toplighting

The overhead sun or a ceiling light fixture produces toplighting. Toplighting fully illuminates only upper surfaces of objects. Toplighting poses no problems to automatic exposure systems because it generally illuminates large areas quite evenly. This evenness, however, may result in somewhat bland landscapes that lack a feeling of depth.

Toplighting creates bland effects because it reduces the feeling of depth in outdoor scenes.

HARD LIGHT AND SOFT LIGHT

As important as the direction of light is the hardness or softness of light. A hard light is directional. It produces brilliant highlights and intense shadows. The bright sun in a cloudless sky gives hard light. Soft, or diffused, lights are less directional. They produce fewer glaring highlights and less intense shadows. Transitions from light to dark are gradual. An overcast sky gives soft light. Hard lighting produces sparkling, often contrasty

pictures. Soft light yields pictures with a smoother, gentler look.

The quality of daylight can change quickly and drastically. If the light isn't what you want, wait a few minutes for a cloud to block the sun or for the sun to descend behind a hill. If you're photographing a person or other movable subject, you might want to move the subject into the shade for soft lighting.

An overcast sky gives soft lighting with unobtrusive shadows and few pronounced highlights.

Like a spotlight, direct sunlight produces hard lighting with brilliant highlights and intense, clearly defined shadows. Notice how the colors differ under hard light and soft light.

COLOR OF LIGHT

We tend to attribute color to the world around us rather than to the light illuminating it. The light itself appears colorless. But it isn't. The sun and most artificial light sources emit light composed of many colors. This is readily demonstrated by a prism splitting sunlight into a spectrum of colors or by nature's prism, the rainbow. Objects show color only when they do not reflect all the colors contained in light. An apple is red because it reflects only the red light striking it and absorbs the other colors of light. White objects reflect all the colors in light.

Although we do not readily perceive the differences, the sun and artificial lights differ in coloration. Fluorescent light is usually greenish. Tungsten light is yellowish. And daylight can vary from blue to white to orange. Our brain, however, adjusts to any slight color variation to provide us with constant color references. Thus, only a trained eye will discern a slight variation in color. Color film does not compensate for color variation. It readily picks up any color changes in light. Once you become aware of these variations, you can use or adjust for them in your pictures.

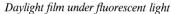

Daylight film under tungsten light

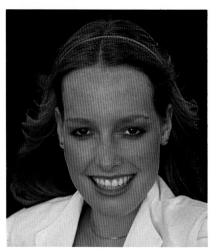

Daylight film under setting sun

Daylight film under midmorning sun

DAYLIGHT

About the only time daylight appears nearly colorless is at midday under sunny skies. Then the light is crisp and clear and shows things in strong, accurate colors. At all other times daylight shows some tinge of color. At sunrise and sunset, it floods the earth with warm hues of yellow and orange. At twilight, in open shade, and on overcast days, it carries a cool touch of blue.

Use these color variations within the light to create mood. The soft yellows and oranges herald an approaching sunset. They start in motion a whole set of feelings about the fleeting daylight. There may be fear of the impending

darkness, awe of the natural beauty, relief and a sense of accomplishment for the day completed. Which feelings a photograph stirs depend in part upon the viewer's psyche and in part upon the subject photographed. A flock of birds darting through the twilight in search of a secure roost will not arouse the same feelings as a laughing face bathed in the warm glow of the setting sun.

The cool blues of an overcast day dampen spirits as effectively as the incessant drip from an eave spout. Through the scene and into the viewer steals the melancholy created by the soft, drab lighting. Without the cheerful clash between bright colors and

A beautiful sunset instills a sense of peace and tranquility. It also signals the fall of night and an urge to seek shelter.

shadows, the day seems subdued. It is characterized by a dim, uniform and lifeless lighting.

With experience, you will learn how to use the color quality of light to reinforce your pictures. You can pick and choose times of the day deliberately to complement the mood you seek.

INDOOR LIGHTING

The most apparent differences between artificial light indoors and daylight outdoors are intensity and color. Indoor lighting is weaker than daylight. Unless you use high-speed films with ISO(ASA) speeds in the 160 to 400 range, exposure times will not permit handholding the camera.

Obvious to color film but not to your eye is the color difference between daylight and artificial light. To obtain normal coloration with tungsten lighting use a tungsten-balanced film such as Kodak Ektachrome 160 Film (Tungsten). With tungsten lighting, daylight film gives pictures with an orange tinge. You can correct for this tinge by using a No. 80A filter with daylight film. It requires a 2-stop increase in exposure. With fluorescent lighting, daylight film usually gives a greenish tinge. Since there is no color film for fluorescent lighting, use a general-purpose fluorescent (FLD) filter or a CC30M KODAK Color Compensating filter with daylight film. Acceptable results are also produced with color negative films, such as KODACOLOR 400, when used with either tungsten or fluorescent lights. Use exposure times of 1/60 second or longer with fluorescent lights. Underexposure may occur at faster shutter speeds because of the pulsing light output of fluorescent tubes.

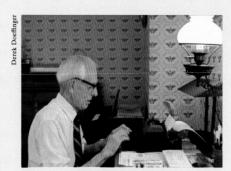

Unfiltered daylight film

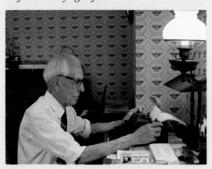

Daylight film with a No. 80A filter

Tungsten light film

Tungsten-lighted scenes are best

rendition.

photographed with tungsten film. Daylight

yellows it gives. Or you can use a No. 80A

filter with daylight film for normal color

film can be used if you like the warm

Without a filter, daylight film records most subjects lighted by fluorescent lights as greenish. An FLD filter or a CC30M filter restores more normal color rendition. A CC30M filter was used for the picture on the right.

Sometimes the subject of a picture can be color itself.

COLOR

The eye revels in the sensory satisfaction provided by color. It also shudders when colors clash. Sometimes you may want to induce that shudder deliberately. Other times you may cause it unintentionally. You can manipulate your photographs through manipulation of color. Soft, muted colors found on a foggy day lend a quiet, pensive mood to a photograph. Bold, brash colors excite and stimulate. Colors influence mood both physiologically and psychologically. Intense reds have long been recognized as exciters, an association perhaps linked to the color of blood.

Color combinations are quieter when they are in harmony. Harmonic colors show similar hues such as green and lime or red and orange or even different brightnesses of the same hue such as pink and red. Colors seem edgy and restless when they contrast. Yellow and blue, green and magenta, these combinations seem to dance before your eyes. Include and exclude colors within the scene to match the purpose of the photograph. If you want to show color for color's sake, go ahead and do it.

Other than including or excluding particularly colored objects from the frame, your color controls are limited. You can wait for the color of light to change or you can use color filters. A color filter colors an entire scene with its own color. Intensely colored filters completely obscure most other colors, while paler filters let many other colors show through, although toned down. You can even use tungsten-balanced film outdoors for bluish colors or daylight film indoors for yellowish colors overall.

TEXTURE

Appeal to the viewer's eye through texture. Texture refers to the surface qualities of an object. Texture is most commonly thought of as smooth or rough, or somewhere in between. Best perceived by touch, texture normally pertains to relatively small areas appropriate to the size and reach of a hand. However, since photography records both large and small subjects on the same size film or paper, subjects of a grand scale can readily show texture in a photograph. A field of boulders or a chain of breaking waves shows texture in a photograph as easily as a tree trunk or a tortoise shell.

To stress rough texture, use sidelighting. Even an orange can be made to appear cobblestone rough. To suppress texture, use diffuse lighting or frontlighting. Either one minimizes surface irregularities.

By showing texture you tell something about the object. You help define what that object is. Moreover, you arouse several other senses and emotions that participate in and react

to the perception of texture. The more you involve the viewer, the more likely that your photograph will succeed. Touch is the most obvious sense involved. It reaches beyond mere awareness of contact between a perceiver and an object. Associated with touch are the sensations of hot, cold, and pain. These are survival sensations and can stir strong responses. Touch also defines something as being hard or soft, dry or wet, dull or sharp. At the moment of contact your fingers quickly report much information. They tell you that a salamander is not only smooth but slippery, that cotton candy is not only gritty but sticky. Texture arouses many senses and feelings. Use it to engage, entertain, and stimulate the viewer's eye and intellect.

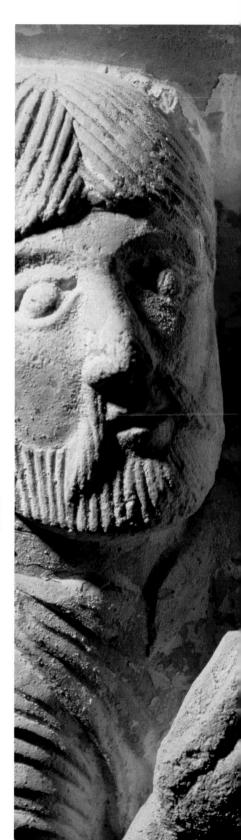

Composition

Composition refers to the arrangement of subjects in a picture. It is sometimes called visual organization or design. Composition determines the visual impact of the finished image. It requires careful deliberation, since you are not only setting the physical relationship between things but may also be trying to elicit an emotional response from the viewer. Following are suggestions that will help you make well-composed photographs.

FRAME THE SUBJECT CAREFULLY

Think of the viewfinder of your camera as a picture frame waiting to be filled. Whatever you choose to include within the frame will be part of the finished picture. Anything you exclude from the frame cannot appear on film. Deciding what to include and what to exclude is a basic and vital decision in making a photograph.

Since most cameras make rectangular photographs, you'll also have to decide whether the picture frame will look better hung vertically or horizontally. Long, wide subjects such as a bridge usually look best framed horizontally. Tall subjects often look best framed vertically. Whenever you think this treatment inappropriate, don't use it. Do whatever is needed to make the subject look good.

With a 35 mm camera, you can emphasize tall subjects by framing the scene vertically. You can stress wide or long subjects by framing them horizontally.

SIMPLIFY

A photograph should depict the subject clearly. A photograph should be clean looking, it should usually contain only a few elements, and it should be arranged in precise order. All too often a photograph is a welter of unrelated subjects clamoring for attention. In the end they all gain a share of the viewer's attention but dilute the impact of the picture. A

Nearly isolated and nearly full frame, this subject is clearly depicted for you to admire or dislike.

good photograph clearly offers one subject for examination.

Fill the Frame

An easy way to simplify a picture is to fill the frame with the subject. You can do so either by moving in close or by using a telephoto lens. Far too

Just as it is hard to talk on a phone amidst the babble of a party so it is difficult to view a subject amidst the clutter of a busy background. Either move the subject in front of a plain background or use a large aperture to throw the background out of focus.

many pictures suffer because the subject is rendered small and inconspicuous. It becomes just another object in the scene. You may not be aware that you are diminishing the subject while taking the picture. Your eyes and mind tend to concentrate on the subject to the exclusion of all else. Your emotions may carry you away. Unfortunately they don't carry away the rest of the clutter and don't influence the camera's perception of the scene.

Shown big, a subject stands out. It poses in proud and glorious detail for all to see. Only people can be shy and retiring and still be appealing. Photographs have to stand up and present their messages clearly.

Sometimes you won't want to fill the frame with a single subject because you are trying to relate several subjects, such as a ramshackle farmhouse beneath a stormy sky or a lone white horse in a shimmering meadow. You aren't featuring a lone subject but a relationship of colors and objects. Still you must simplify for the photograph to succeed. A white horse grazing on a green, treeless hill with a sliver of blue sky at the top is simple. It consists of only three things. But a white horse grazing on a randomly treed hill with a rusting tractor here, an abandoned wagon there, and roving kids everywhere is not so simple. When a picture has more than three or four elements, it becomes harder to handle. It can be handled, but make it easier for yourself by holding the picture elements to a minimum.

Although minimizing the number of elements and subjects in a picture often simplifies the task of composition, this

photographer easily handled several elements through a well-chosen arrangement and viewpoint.

981 Hamilton S

SILHOUETTES

Silhouettes produce the most dramatic simplification of all. Silhouettes strip away color, texture, and mass. Thousands of details are reduced to one element-shape. Only contours are left for the viewer to consider. In real life one is seldom forced to rely on contours alone. The eye and brain usually start with shape and quickly search for more information. With a silhouette a photograph can readily exclude all but shape. The eye leaps at silhouettes, devouring the sloping, curving, angling contours. The success of silhouettes may derive from their brevity. They show enough to tell the viewer what he's seeing but they hide enough to fire the imagination. Silhouettes are easily made by underexposing when the subject is backlighted or in front of a bright background such as a white wall or sun-reflecting water.

Perhaps the simplest of all pictures is the silhouette. Visual information is stripped down to the barest essential—shape.

VIEWPOINT

Since most cameras are designed to be used at eye level and since humans are upright creatures, most pictures are taken from eye level while the photographer is standing. There is nothing wrong with this. But it can become tiresome to see the same viewpoint used time after time. An abrupt departure from a standard angle can produce an arresting photograph.

Always look for better camera angles. They can turn a prosaic subject into a fascinating subject.

Vary your viewpoints. Supplement overall views with close-ups of details. Make a practice of taking several pictures from different distances and sites when confronted with a subject of unusual appeal. Often, the best picture develops gradually as you experiment with different points of view.

Photographed from a normal, standing position, above, this child sliding down a pole looks pleasant enough, though quite prosaic. Photographed from the ground, right, the same child sliding down the same pole now appears dynamic. Viewpoint can make the difference.

ASYMMETRY

Don't succumb to that seemingly irresistible draw that pulls the camera until the subject registers in the center of the frame. Move subjects away from the center. Left to languish in the center, many subjects seem dull and boring. They divide the picture area into regular portions. The right side receives no more emphasis than the left, the top no more than the bottom. Such regularity quickly dulls the viewer's eye.

By moving the subject off center you add pace and variety. You invite the eye to explore and wander about the photograph. The eye compares the weights given to various areas of the picture. It enjoys the variety of unequally divided spaces and, if satisfied that the results justify the treatment, will give its approval. If unsatisfied, it has nonetheless been momentarily entertained by the variety.

Normally, the subject will look best when moderately off center. Perhaps a third of the way up and to the right, or in the lower fourth of the picture. Yet don't ignore the possibility of extreme placement. Some subjects justify extremes.

SYMMETRY

Should you ever use the symmetry offered by placing the subject in the center of the picture? Of course. When? Why, when it works. That simplistic answer is more profound than it seems. There are no unbreakable rules of composition. What works often works in spite of any guidelines. So if the subject looks better in the center of the frame, place it there. Subjects that look better with central placement often show great symmetry. The central placement reinforces that symmetry and in fact makes the symmetry itself the subject, rather than the subject actually photographed.

Placing the subject off center often makes for a more interesting picture.

The symmetry of the balloons is reinforced by careful composition. Any far off-center placement in the picture would have unbalanced the picture.

LINES AND SHAPES

Take advantage of strong lines, curves, shadows, and shapes in the scene. They let you take the viewer's eye on a controlled excursion through the photograph. A bold feature, such as a road leading toward the subject or a shaft of light picking

the subject out of darker surroundings, provides an irresistible path for the eye. Look for such elements when you compose the picture. Put them to work for you.

Some things the eye just enjoys viewing. Strong lines and curves made by these walls and door are among those things. The eye is no doubt pleased by the order they present.

COUNTERBALANCE

Counterbalance occurs when you play off visual opposites against each other. Examples of counterbalance are light against dark, smooth against rough, angle against curve, colorful against drab. Opposites push and tug against each other.

While opposites may not attract each other, they do attract onlookers—in this case, the viewer. They create tension. Sometimes the tension is physiological, for instance, as the eye alternately tries to adjust for the black-and-white stripes of a zebra, or when fingers simultaneously feel both the smoothness and roughness of a marble in sand.

In counterbalancing opposites, each need not receive equal treatment. A black cat creeping below a white snowdrift can be shown taking up considerably less area than the snowdrift. The bright square of light of a mine shaft opening into daylight sufficiently counteracts a massive darkness that signals the interior of the shaft. In fact, greater emphasis is often given to a small counterbalance. It stands out by its smallness. The more equal treatment given the counterbalances, the less tension exists between them.

Several counterbalances work to make this picture. The cliff is massive. The boat is small. The cliff is shadowed. The boat is sunlit. The cliff is craggy and natural. The boat is smooth and manmade.

The subject

In the end, all you know about photography must be molded to a particular subject. Metering, camera handling, lighting, color, and composition must all meld together to showcase the subject. Yet different subjects require different approaches. A landscape may require sharpness; an action shot may not. A barn doesn't mind being stared at; a person does. We'll examine some techniques and ideas in photographing three favorite subjects: people, landscapes, and action.

eil Montanus

PEOPLE

Pictures of people invariably fall under two broad categories: portraits and candids. Portraits tend to be formal and posed. Candids tend to be informal and spontaneous.

18 mm lens

Portraits

A good portrait reveals the nature of the subject. It may also tell us how the photographer feels about the subject. Pose, facial expressions, and props all can reveal the character of a person. Most portraits of individuals are tightly framed to direct the viewer's attention to the subject's face.

In a tightly framed portrait, have the subject gaze directly into the lens. That direct eye contact will engage the viewer. Focus carefully on the subject's eyes. If they look sharp, the picture will be perceived as sharp.

When using a normal lens for portraiture, avoid filling the frame with your subject's face or distortion will result. The close shooting distance exaggerates perspective. It makes the nose disproportionately large when compared with the ears and other parts of the face. You can avoid this unpleasant effect, by using a lens with a focal length in the 80 to 135 mm range. If you cannot use a longer lens, you can avoid distortion with a normal lens by keeping the camera-subject distance greater than 3 feet (1 m).

50 mm lens

Soft, diffused lighting such as on an overcast day or in the shade is excellent for portraiture. It minimizes facial imperfections and doesn't cause squinting. With color transparency films, shooting under heavy overcast or cloud cover yields slides with a cool, bluish cast. For scenery and pictures of objects, the cool rendition simply maintains the feeling of the weather. The cast may be unpleasant, though, in pictures of people. To warm up skin tones in portraits, try a No. 81A or a No. 81B filter.

Forty-five-degree sidelighting can make a face look dynamic. Shadows indicate depth and size of facial features. A strong face is usually further strengthened by sidelighting. Use a reflector or fill-in flash to lighten any excessively dark shadows.

Since the face should dominate in a portrait, background clutter should either be avoided or rendered out of focus with a relatively large *f*-stop.

Facial distortions appear in head-andshoulder portraits unless a lens in the 80 to 135 mm range is used. A 50 mm lens can be used if the camera-to-subject distance is increased by a few feet or if the subject tilts his head somewhat to the side.

105 mm lens

Eyes gazing directly from a photograph readily grab the viewer's attention. The subject can easily tilt her head in a different pose and still glance toward the lens.

Bob Clemens

The harshness of frontlighting can wash out subtle facial tones and cause squinting.

The shadows created by sidelighting round out the face and define the form of cheeks, nose, and lips. Shadows can be lightened with a white cardboard reflector.

Toplighting causes unattractive shadows beneath the eyes and a drooping nose shadow. Again, a reflector can reduce the shadows.

Perhaps the best of all light for portraiture is the soft, even light of an overcast day or of bounced flash. Shadows are slight, hues are many, and the face is shown at its best.

Backlighting adds an attractive highlight to the hair but can cause underexposure, as happened here. With backlighting the face is actually lit by diffuse skylight.

For backlighting, opening the aperture 1 or 2 stops exposes the face properly but overexposes the background. Either minimize the background with a full-frame portrait or seek a darker background.

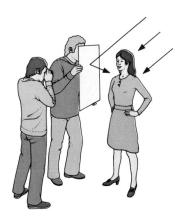

In this backlighted portrait, the photographer used a reflector to light up the face and avoid a burned out background.

In this backlighted portrait, the photographer used fill-in flash to lighten facial shadows.

PORTRAITS OF COUPLES AND GROUPS

The relative positions of the subjects tell the story when making portraits of two or more people. A couple brushing shoulder to shoulder suggests more love than a couple 5 feet (1.5 m) apart. Eye contact is equally important. With small groups try for a triangular composition. By giving the group some form, you avoid sloppy composition. If there is a hierarchy to the group, the leader should be positioned prominently. From a purely practical standpoint, for large groups arrange taller persons in the back and shorter ones in front. Some groups might settle into a natural arrangement better than anything you can design. Give them a try before imposing your arrangement. Be sure to use a small enough aperture to provide a sharp picture of the entire group.

When you are using a flash unit for group portraiture be aware that direct flash falls off in brightness quite quickly. A group arranged front to back will be much brighter up front than in back. To avoid this, either use bounce flash, which is much more even, or arrange the group to minimize its depth.

Eye contact, distance, posture, and facial expressions all contribute to the perception of the relationship between these two people.

Neil Montanus

CANDIDS

Candid photographs depict spontaneity. They almost always show people doing something of their own choice, unlike portraits in which the subject is either posed or handling props arranged by the photographer. In a candid photograph the subject's actions give the viewer personal insight into that person and consequently insight into human nature in general. An adult slipping down a slide or a child soldering together a radio kit says quite a bit about the nature of that person. And it comes from the person, not the photographer.

Though spontaneous, many candid photographs are carefully planned by the photographer. Assume that you spot a large puddle at a busy intersection. You can safely predict that patience will reward you with pictures of people leaping the puddle or leaping away from the spray of passing cars. Whether or not they avoid a soaking, you will be the beneficiary of their efforts.

An automatic camera is ideal for candid photography. It frees you of exposure worries to concentrate on the subject. Set the focus ahead of time. If possible, use a telephoto or a zoom telephoto lens so you can work unobtrusively from a distance. Once your subject becomes aware of you, self-consciousness might destroy any spontaneity.

For indoor photography use high-speed film such as KODACOLOR 400. When possible, avoid flash. It can disrupt the naturalness of people and indoor lighting. Finally, be courte-ous. Don't take pictures of someone who doesn't want to be photographed.

The unguarded spontaneity of a candid photograph conveys a naturalness rarely found in portraits. A candid often tells us as much about ourselves as about the subject.

CHILDREN

Children are best photographed candidly. Although you can dress and groom a child neatly for a formal portrait, the resulting photograph seldom reveals the true character of the child. Few children would qualify for the best-dressed list.

Children differ from adults in two significant ways. They are smaller. They are more active. You can deal with the size factor easily enough. Simply kneel and shoot at eye level with the child. If you don't, you'll soon find yourself looking at a stack of pictures showing only the tops of heads.

Photographing active youngsters requires a few special techniques. If the child is dashing about in a playground or backyard, it may be impossible to focus as fast as the child moves. Instead of trying to follow the child, focus on one spot at a predetermined distance. Note several landmarks (a stone or a flower) that are roughly that distance from your camera. When the child passes near any of these landmarks begin taking pictures. Keep an eye on your shutter speed. A shutter speed of 1/125 second may work for hopscotch but not for hide and seek. Given the liveliness of kids, you can make your own life easier by using a high-speed film and taking along a flash unit, just in case.

To bring a child to a standstill, you need to engage and hold his or her attention. You might achieve your aim by starting a conversation or providing an interesting toy.

If you photograph a child from a standing position you'll either get a picture of the top of the child's head or the child's head awkwardly craned back looking up at you.

For the best pictures of kids, get down to the child's level where the viewpoint appears normal.

Full of charm and seldom inhibited, children have no trouble acting natural before a camera.

ACTION

There are two ways to record action: sharp and blurred. Each has its advantages. When a subject you are photographing moves during the exposure, its image moves on the film inside the camera. If the movement of the image is minimal, a sharp picture results; if the movement of the image is great, an unsharp picture results.

Other important factors to consider when photographing moving subjects include the direction of motion relative to the camera and the size of the image on film, which is a function of subject distance and lens focal length.

Shutter Speed

The most important single factor in controlling the way a moving image is recorded is the length of time the image is permitted to move on the film.

To stop motion with aperture-priority cameras, choose a large aperture. The camera automatically selects one of the faster speeds possible. Check the depth of field and look for possible overexposure in bright light. With a shutter-priority automatic camera, set the shutter to the speed required to stop the motion. When in doubt as to that shutter speed, use the fastest speed possible.

Image Size on Film

Magnifying the image also magnifies its motion on film. It doesn't matter whether an increase in image size results from decreasing the camerato-subject distance or from changing to a longer focal length lens. With a given lens, the closer you are to a moving subject, the faster the shutter speed you must use to record it sharply.

A sharp action shot reveals an instant in a rushing flow. Caught in midair tumble, these skiers momentarily show ballet gracefulness before ploughing into the snow.

By introducing blur into an action shot you convey the sense of movement: the pumping legs, the rushing air, the exhilaration.

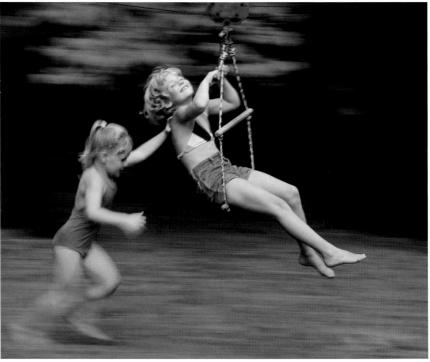

on Savage

DIRECTION OF MOTION

When all else is constant, actionstopping shutter speeds vary with the direction of movement. The slowest action-stopping shutter speeds are for subjects moving directly toward or away

A subject crossing directly in front of the camera requires a faster shutter speed to stop action than a subject moving in any other direction.

1/1000 second

1/250 second

1/60 second

from the camera. The fastest are for subjects crossing in front of the camera (parallel to the camera back). Shutter speeds in between the other two stop action of obliquely moving subjects.

A relatively slow shutter speed can stop motion of a subject moving directly towards or away from the camera.

1/60 second

1/30 second

1/15 second

Stopping the motion of a subject moving obliquely requires a shutter speed intermediate to the speeds needed for the other two directions of subject movement.

1/500 second.

1/125 second

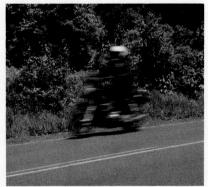

1/30 second

Neil Montanus

STOP ACTION WITH FLASH

The sharpest renditions of moving subjects are generally produced by electronic flash. The flash duration rather than the camera's shutter speed represents the exposure time. That duration can be extremely short. For small flash units, it typically lasts 1/1000 second or less. For some larger automatic flash units, the flash duration is as short as 1/50,000 second. As a matter of courtesy, refrain from taking flash pictures when they might distract athletes, entertainers, or spectators.

The lightning-like burst of an electronic flash makes it ideal for stopping fast movement, such as this girl who seems to be levitating but is actually working out on a trampoline.

PEAK ACTION

Many subjects that have peak action can be photographed with fairly slow shutter speeds. The characteristic these subjects share is that at some point in their path they slow down appreciably before accelerating once more. The classic example is a diver springing into the air. The diver rises from the board rapidly at first, then reaches an apparently motionless peak before regaining speed in the descent to the water. When the diver is at the peak, a shutter speed as slow as 1/125 or even 1/60 second may give a sharp image. Even when stopping motion is not a problem, pictures made at a peak instant are often dramatic because of the feeling of anticipated acceleration. The peak does not have to represent an actual peak in a rising and falling path. It may simply be a slowing such as a running back reversing direction. The more you know about the type of action you are photographing, the easier it will be for you to foresee action peaks in time to take advantage of them.

Many moving subjects reach a slowing or stopping point before accelerating again. At the point of slowdown, a fairly slow shutter speed of 1/60 or 1/125 second can often freeze motion.

DELIBERATE BLUR

Sometimes recording a moving subject sharply results in a picture that looks static, with no real feeling of motion. If everything in the scene looks sharp, you may have no way of telling that a race car was actually thundering along the track at nearly 150 miles (250 km) per hour. If you introduce a carefully controlled amount of blur into the picture, though, you can bring back some of the excitement the race car generated when you watched it. One of the most successful techniques for making exciting blurred-motion pictures is panning.

Panning

Panning consists of smoothly tracking a moving subject in the camera viewfinder while making an exposure at a slow shutter speed. This is one of the rare instances when camera movement during the exposure is desirable. For maximum effect, the subject should be crossing in front of

you. The resultant picture shows a sharp image of the moving subject against a blurred background. Here's how to do it.

Let's say you're at a harness race, with a clear view of a straightaway. The sulkies zoom past you from left to right. First, focus on a part of the track opposite your position where you expect a sulky to pass. When the sulky approaches, begin tracking it in the viewfinder. When it reaches the spot you focused on, press the shutter release, and continue moving the camera, maintaining a smooth follow-through. If you don't follow through, you might stop camera movement at the moment of picture-taking and lose the desired effect.

The slower the shutter speed, the more the background will streak, creating a sense of rapid movement. On the other hand, the longer the shutter is open, the greater the chance of recording the sulky less sharply than desired. There are no precise

When panning, be sure to follow through with the motion to obtain the desired effect.

answers to the question of which speed to try. Start out with a shutter speed fraction that approximates the reciprocal of the speed of the moving object in miles per hour (1/30 second for 30 mph). Use shutter speeds double and half this beginning speed. On bright days you will need a mediumor slow-speed film to obtain slow shutter speeds. You will also have to use very small apertures such as f/16. A neutral density filter can help you obtain slow shutter speeds with faster films by blocking light without altering the color.

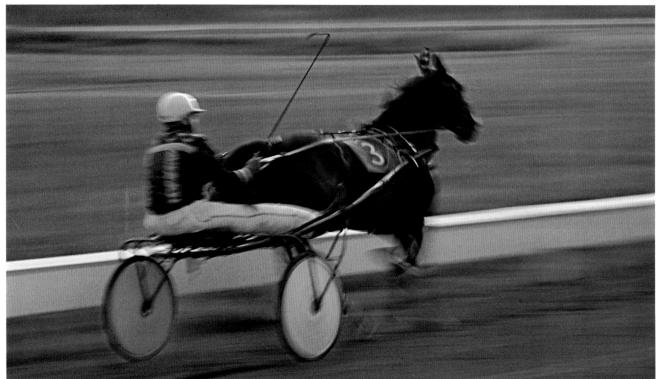

hn Phelps

Blur: Camera Steady

An opposite approach to panning the camera is to keep the camera immobile on a tripod and make a relatively long exposure while the moving subject passes through the field of view. Depending on the speed of movement and the shutter speed, the subject may exhibit slight to pronounced blurring, while static parts of the scene register sharply.

Select a film with sensitivity appropriate to the anticipated light level. Or take along a neutral density filter to get slow shutter speeds. Besides obvious applications to sports subjects, allowing motion to blur during an extended exposure can produce subtle and lovely effects in pictures of natural subjects. The blur of motion softens breaking surf poetically and contrasts it with sharply rendered rocks or jetties. Leaves and grass moving in a breeze can become impressionistic masses of color in a landscape. As with panning, experiment to learn which shutter speeds to try first, and take several versions of each shot at a variety of shutter speeds.

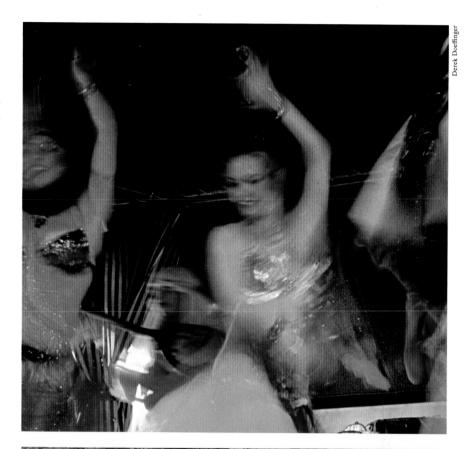

By holding the camera steady and allowing the moving subject to create its own blur, **above**, you can produce startling images. The subject is portrayed in a way we do not normally see.

A slow shutter speed of 1/8 second turns the crystalline clear rivulets of a stream into a soft, white blur of water.

LANDSCAPES

To many people, landscape photography means capturing the breathtaking view from a roadside lookout or photographing that gorgeous chain of mountains against the deep blue sky. Landscape photography is that and more. It goes well beyond the postcard view of magnificent scenery. Instead of a rolling plain, it can be a crowded parking lot. Instead of a pastoral farm scene, it can be a jagged city skyline. It can be a flaming cloud at sunset, a shimmering reflection in the water, a solitary wave crashing against a rock. It can be a moonrise, a smokestack, a cooling tower. Landscape photography ranges so widely that it affords many opportunities. Most of us choose to photograph natural beauty, but the other side of landscape photography is equally valid.

There is a miraculous aspect to compressing miles of scenery onto the surface of a small piece of film. Nonetheless, resist the urge to cram the maximum amount of scenery into every picture. Reducing the horizon to the width of a frame of film diminishes the visual impact. Excessive miniaturization lessens the importance of key features. Concentrate on a significant segment of the scene. Show the subject clearly.

Although the configuration of a landscape may be relatively permanent, its appearance constantly changes. Time of day, time of year, the weather, and other factors affect a landscape's appearance. Weather

The most common landscape photographs are of pleasant pastoral scenes, such as this forest in the early morning mist. By tradition, landscapes have ranged from awe-inspiring mountains to relaxing country scenes.

HORIZON POSITION

Unless you are photographing a very symmetrical scene, the horizon should not cut across the center of the picture. A high horizon confines the viewer to the earth, leaving the eye to roam the land, symbolizing great distances to be traversed. With a low horizon, the earth and its structures are dwarfed by a great expanse of sky suggesting spaciousness.

When placing the horizon low, be aware that the bright sky may lead the meter into underexposing the terrain. To show detail in the land, establish the exposure by aiming the camera slightly down to prevent the meter from reading an excessive amount of sky. Note the indicated exposure, then reframe the scene. Check the meter readouts again. If they differ substantially from the original reading, use the compensation control to obtain a compromise exposure that will not make the sky too light or the ground too dark.

A high horizon directs attention to the water. The eye travels from the ripples in the foreground to the canoe.

A low horizon suggests spaciousness and freedom. The sky dwarfs the canoe, showing how small it actually is. The viewer's eyes are freed to stare off into space, an action associated with daydreaming.

and time of day may be the two factors you can most readily take advantage of. When seen under brilliant skies and then in a blizzard, the same landscape varies tremendously. By far, most people take landscape pictures under sunny skies, which allow them comfort and produce a scene as normally viewed. The resulting photograph is often satisfying in that it shows the scene clearly and is cheerful because almost everyone loves sunny weather.

Most landscape photographs do not require high shutter speeds, as there is little subject motion that must be stopped. However, extensive depth of field is often needed to yield sharpness from foreground to background. To obtain such sharpness, use a small aperture to maximize the depth of field.

You will often be using small aper-

tures to produce sharpness throughout the photograph. By using a slow- or medium-speed film you can reinforce that sharpness with a nearly grainless image. KODACHROME 25, KODACHROME 64, KODACOLOR II. and PANATOMIC-X Films record scenics with superb clarity. Sometimes you may want the stability provided by a tripod. With a slow-speed film, small f-stops often mean slow shutter speeds. With a normal lens you may escape blur from camera movement at a slow shutter speed, but don't try it with a telephoto lens. With long lenses, mount the camera on a tripod. High-speed films also give good results and seldom require the use of a tripod.

Placed across the middle, a horizon forces the viewer to look separately at the top and the bottom halves of the picture. An evenly divided picture seldom works unless the subject is symmetrical.

Glowing banners of smoke flowing from smokestacks and greenish lights and reflections lend an eerie beauty to an industrial complex. Photographed during the day, the same scene would undoubtedly be quite drab. With high-speed film or a tripod and an automatic camera, nighttime scenes are easily photographed.

Landscape photography goes beyond the land. This brilliant sunset sky is also a "landscape." Reflections in the water, city skylines, and many other atypical landscapes are part of landscape photography.

WEATHER AND LANDSCAPE

Stormy weather inspires awe and fear. Who doesn't remember the blizzard of '66 or the wedding getaway in which the couple was pelted not with rice but hail? Use stormy weather in your landscape photography. Venture into a snowstorm or rainshower. Photograph the thunderheads looming over the horizon or the trees bending in the gale.

Even dull, overcast days can be useful. The nearly shadowless illumination that is so good for making pleasant pictures of people also can be used in landscapes. Under the soft, uniform lighting, colors look livelier. The absence of glaring highlights that dilute color, and can wash it out altogether, allows the film to record virtually all the color in the scene.

Since bad weather means dim light, you will probably want to take along some high-speed film or a tripod. Kodacolor 400 and Kodak Ektachrome 400 Films are good choices. You will also want to protect your camera from snow and rain. You can survive a drenching; your camera may not. Water is a deadly enemy of your camera's electronic circuitry.

Ideally, you and your camera will both function best if a cooperative friend or relative stands by with a big umbrella to shelter you. Such nobility of spirit being rare in the world, wear a wide-brimmed hat to help keep you and the camera reasonably dry. A lens shade is useful, even though there's no sun in sight, to keep stray raindrops or snowflakes away from the lens surface.

In heavy precipitation, you can protect your camera by improvising a raincoat for it. Slip the camera into a large, clear plastic bag with the lens pointing toward the closed end. Use rubber bands to hold the end of the bag tightly around the lens shade. Carefully cut away the plastic stretched over the opening in the lens shade. Insert your hands through the

open end of the bag to operate the camera.

In cold weather, if the temperature is 32°F (0°C) or below, keep your camera inside your coat when you are not taking pictures. The batteries lose power at low temperatures. Keeping the batteries warm keeps them functioning.

Snow as well as sand is an efficient reflector of light. When taking pictures of snowy fields or sandy beaches, increase the recommended exposure by 1 or 2 stops. If you do not, the snow or sand will appear grayish, while other subjects are even more underexposed.

To protect your camera from rain or wet snow, place it in a plastic bag with the bottom cut out so the lens can poke through.

Driving snow and a man behind the plow combine to produce a powerful photograph of man against the elements. Bad-weather pictures often arouse strong feelings that involve the viewer in the photograph.

Recommended reading

One of the continuing pleasures of photography is that there is always something new to learn. Whether it is new to you simply because you haven't learned it yet or because it's whistling in on the cutting edge of a new technology hardly matters. The more you learn about the medium, the better equipped you will be to use

The Joy of Photography

AC-75H (hardcover), \$19.95 AC-75S (softcover), \$11.95

A thorough guide for both the beginning and advanced photographer, this book covers the technical and creative aspects of photography. It carries you from camera handling into the darkroom, delves into photographic equipment, and explores the many ways of building a picture. Individual subjects such as landscapes, sports, nature, and people are also studied. 302 pages. ISBN 0-201-03916-8

it to your full potential, and the more pleasure you'll get from it. The following Kodak publications elaborate on ideas and methods presented in this book, or introduce concepts that had to be omitted in the interests of brevity and simplicity.

Ask your photo dealer for these publications. If your dealer cannot

KODAK Guide to 35mm Photography

AC-95H (hardcover), \$19.95 AC-95S (softcover), \$9.95

Loaded with photographs, this book will familiarize you with camera handling, Kodak films, exposure, flash, equipment, composition, and more. The pictures show you where it's at. The text shows you how to get there. 285 pages. ISBN 0-87985-242-9

More Joy of Photography

AC-70H (hardcover), \$24.95 AC-70S (softcover), \$12.95 This is the book for the photographer who likes creative techniques. The first two chapters tell you how to develop your own personal creative style and how to use camera controls supply them, you can order by title and code number directly from Eastman Kodak Company, Department 454, Rochester, New York 14650. Please enclose payment with your order, including \$1.00 for handling plus applicable state and local sales taxes. Prices are subject to change without notice.

creatively. A third chapter explodes with 100 creative techniques covering topics like painting with flash, hand-coloring photographs, using time lapse, and photographing mirror reflections. 288 pages. ISBN 0-201-04544-3

KODAK Films—Color and Black-and-White

(AF-1), \$5.50

Reference book to Kodak films for general use. Text portion tells how to choose the right film and how to use it properly for best results. A data sheet section gives all the details for each film. Tables summarize the information for convenient reference. 164 pages. ISBN 0-87985-161-9

KODAK BLACK-AND-WHITE FILMS FOR 35 mm CAMERAS

KODAK Film	Description	ISO/ASA speed	Number of exposures available
Panatomic-X	An extremely fine-grain panchromatic film with very high sharpness for big enlargements.	32	135-20 135-36
PLUS-X Pan	An excellent, general-purpose panchromatic film that offers the optimum combination 125 of fast speed and extremely fine grain.		135-20 135-36
Tri-X Pan	A high-speed panchromatic film especially useful for photographing existing light subjects, fast action, subjects requiring good depth of field and high shutter speeds, and for extending the flash-distance range. This film has fine grain and excellent quality for such a high speed.	400	135-20 135-36
Recording 2475	An extremely high-speed panchromatic film for use in situations where the highest film speed is essential and fine grain is not important to you, such as for taking action photographs where the light is extremely poor. The film has extended red sensitivity and coarse grain.	1000	135-36
High Speed Infrared	An infrared An infrared-sensitive film which produces striking and unusual results. With a red filter, blue sky photographs almost black and clouds look white. With this film and filter, live grass and trees will appear as though they are covered by snow. This film has fine grain.		135-20

^{*}Use this speed as a basis for determining your exposures with tungsten light when you expose the film through a No. 25 filter. In daylight, follow the exposure suggestions on the film instruction sheet.

Note: Panchromatic means that the film is sensitive to all visible colors.

KODAK COLOR FILMS FOR 35 mm CAMERAS

				ISO/ASA Speed and Filter				
KODAK Film	Description	Type of picture	For use with	Daylight	Photolamps 3400 K	Tungsten 3200 K	Number of exposures available	Processed by
KODACOLOR II	A fast, general-purpose, color negative film that yields color prints. Features extremely fine grain, wide exposure latitude, and good versatility.	Color prints	Daylight, electronic flash, or blue flash	100	32 No. 80B	25 No. 80A	135-12 135-24 135-36	Kodak, other labs, or user
Kodacolor 400	A high-speed, color negative film for color prints. Use this film for photographing existing light, fast action, subjects requiring good depth of field and high shutter speeds, and for extending the flash-distance range. The film has wide exposure latitude and great versatility.	Color prints	Existing light, daylight, electronic flash, or blue flash	400	125 No. 80B	100 No. 80A	135-12 135-24 135-36	Kodak, other labs, or user
Kodachrome 25 (Daylight)	A popular color slide film noted for excellent color and high sharpness. It has extremely fine grain and good exposure latitude.	Color slides	Daylight, electronic flash, or blue flash	25	8 No. 80B	6 No. 80A	135-20 135-36	Kodak and other labs
Kodachrome 40 5070 (Type A)	A color slide film designed for use with 3400 K photolamps. It gives high-quality color rendition and exceptional definition. This film is excellent for informal portraits, close-ups, title slides, and for copying color originals. You can also take pictures in daylight with the recommended conversion filter.	Color slides	Photolamps 3400 K	25 No. 85	40	32 No. 82A	135-36	Kodak and other labs
KODACHROME 64 (Daylight)	A medium-speed, general-purpose film for color slides. Its extra speed is an advantage in many situations, especially when lighting conditions are less than ideal. Exhibits remarkable sharpness and freedom from graininess. Color rendition of this film is excellent.	Color slides	Daylight, electronic flash, or blue flash	64	20 No. 80B	16 No. 80A	135-20 135-36	Kodak and other labs
EKTACHROME 64 (Daylight)	A medium-speed, color slide film for general all- around use. It has sufficient speed to let you use higher shutter speeds or smaller lens openings in normal lighting or to let you take pictures when the lighting is somewhat subdued. This film produces vivid color rendition and excellent sharpness and graininess characteristics.	Color slides	Daylight electronic flash, or blue flash	64	20 No. 80B	16 No. 80A	135-20 135-36	Kodak, other labs, or user
EKTACHROME 200 (Daylight)	A high-speed, color slide film for existing light, fast action, subjects requiring good depth of field or high shutter speeds, and for extending the flash-distance range. It has very fine grain and excellent sharpness. This film can be push-processed to double the speed.	Color slides	Daylight, electronic flash, blue flash, or existing daylight	200	64 No. 80B	50 No. 80A	135-20 135-36	Kodak, other labs, or user
				400* 125* No. 80B	125* No. 80B	100* No. 80A		
EKTACHROME 160 (Tungsten)	A high-speed, color slide film for use with 3200 K tungsten lamps and existing tungsten light. It features the same very fine grain and excellent sharpness as the 200-speed Daylight film. This film can be push-processed to double the speed.	Color slides	Tungsten lamps 3200 K or existing tungsten light	100 No. 85B	125 No. 81A	160	135-20 135-36	Kodak, other labs, or user
				200* No. 85B	250* No. 81A	320*		
EKTACHROME 400 (Daylight)	A very high-speed, color slide film for existing light, fast action, subjects requiring good depth of field and high shutter speeds, and for extending the flash-distance range. The film is very helpful for pictures under adverse lighting conditions. It has fine grain and good sharpness. This film can be push-processed to double the speed.	Color	Daylight, electronic flash, blue flash, or existing daylight	400	125 No. 80B	100 No. 80A	135-20	Kodak,
				800*	250* No. 80B	200* No. 80A	135-36	other labs, or user
EKTACHROME Infrared	A false-color film for color slides. It's used in such fields as aerial photography, science, and medicine, but it's also useful for unconventional pictorial photography where abstract, unrealistic colors are desired.	Color	Daylight, electronic flash, or blue flash	100 No. 12 or 15	50 No. 12 or 15 plus CC50C-2	_	135-20	Kodak, other labs, or user

^{*}With Kodak Ektachrome 160, 200, and 400 Films in 135 size, you can use these higher film speeds—2 times the normal film speed—when you send your film for processing in the Kodak Special Processing Envelope, ESP-1, sold by photo dealers.

Index

Action photography 24, 84–89	Exposure latitude 56–57
autowinders and motor drives 51	Exposure meters 17
children	Extension tubes 50
creating blur 88-89	Film
panning	exposure latitude 56-57
peak	graininess 51
Aperture	increasing speed of 57
Aperture-priority automation 24	indoor
Asymmetry	loading 110 and 126 cameras 14
Automatic focusing 9, 13	loading 35 mm cameras 33
Autowinders and motor drives 50–51	processing from Kodak 56–57
Backlighting	roll
Bracketing	sharpness
Camera cases	speed of
Camera holding	speed-setting dial 21
Camera protection 92	tungsten-balanced 66
Cameras	types of
aperture-priority 24	Film chart
cartridge-loading	Film speed dial
cleaning	Filters
instant	conversion
multi-mode	shade
programmed automation 25	Fluorescent lighting 66
roll-film	Focusing
shutter-priority	automatic 9
35 mm SLR 9–11	rangefinder
35 mm with optical viewfinder 12–13	SLR
Candids 82	zone symbols 9
Children	Frontlighting 59
Close-up lenses 50	portraits 80
Color	Guide numbers 41
of light 64	Landscapes 90–93
Counterbalance	horizon position 90–91
Depth of field 19, 30, 31	Lenses
Depth-of-field scale	affect on perspective 31
Direct optical viewfinders 9	focal length 27
Electronic flash	macro 29
bounce flash 44-45	normal 28
exposure with 40–41	portraiture 79
fill-in flash 42	telephoto 28
guide numbers 41	wide-angle 28
off-camera flash 43	zoom
shutter speeds for 38	Lens shades 47
stop action with 86	Light
synchronization	backlighting 61
types of	color of
Exposure	daylight
automation of 24–25	direction
backlighting	frontlighting 59
bracketing 23	hard 63
controlling 18, 19	indoor
creative	portraits 80–81
flash	sidelighting
sidelighting	soft
special controls 21	toplighting 62
when to vary	Lines and shapes 76

Exposure latitude 56–57

Loading film
110 and 126 cameras 14
35 mm cameras
Motor drives 50–51
Multi-mode automation 25
Panning
People
lighting for 80
Portraits
group
lenses for 79
lighting for 80–81
Programmed automation 25
Rangefinder9, 12
Shutter
Shutter-priority automation 24
Shutter speeds 18, 20, 33, 84
electronic flash 38
Sidelighting 60
portraits 80
texture
Silhouettes 61, 73
Simplifying the picture 72
Single-lens reflex cameras 10-11
Symmetry
Texture
Tripods
Tungsten lighting 66
Viewfinders
optical
SLR 10
Viewing systems
Viewpoint
Weather